MW01535342

``

After Shtisel

Analyzing Season Three and *Autonomies*

by

Maurice Yacowar

published <u>lulu.com</u>

Part One

Shtisel — Season Three

The Story so Far

First off: We didn't need a third season. The first profound, thoroughly engaging work was conceived as a dramatic two-season whole — complete in itself. Only the unexpected international enthusiasm for the series and the clamour for a continuation led to a sequel. I confess to having been concerned. Why gamble with perfection?

Spoiler alert: The sequel lives up to the original richness. There is no lessening of power, complexity and ambition in the script by Ori Elon and Yehonatan Indursky.[1] There is only polish and power in the performances, direction and production values. Hence this sequel to my earlier study, *Reading Shtisel*.

Before venturing into the third season it may be worth striking an overview upon the first two seasons. The two-season drama is framed by incidents involving the image of the dead Dvora. It opens with Akiva's dream of his mother, feeling frozen. Over the two seasons we will watch Akiva and Shulem — who claims the dream as his own, so unsettling is it — come to terms with the loss of Dvora, their mother and wife, respectively.

For Akiva, his immediate response to his mother's cold is to offer a heater service to the needy. He then seeks to establish his own family and to become an artist. As he grows from son into husband his first serious courtship is — logically — with a woman who is already a

[1] Yosa'le's story here is credited to Rabbi Chaim Walder's collection of true life stories, *People Speak*.

mother, the twice-widowed Elisheva. When he fails to mount the courage to move to London with her he falls prey to the manipulating Esty, but later finds love in his cousin Libbi.

For Shulem, the dream compels him to remember the many times he disappointed his wife. From refusing her wish to replace the kitchen chairs to denying her nightly phone calls from young Akiva at yeshiva, Shulem has denied her every desire. Dismissing all his children's ambitions as "fantasy," he personifies the destructiveness of patriarchal authority. As this numbs his own emotional life, Shulem is himself a victim of his ostensible power. He loved Dvora but never deigned to tell her. Now his tears are too late.

In his final scene (II,12) he is blindly determined to make up for that neglect. He attacks Akiva over his painting of the ideal of motherhood. Ostensibly to protect Dvora's honour Shulem betrays her most earnest deathbed wish. To procure — and spoil — her favourite Akiva's best painting Shulem sells the burial spot that Dvora had begged him to buy, to be together in eternity. To make up for his 30-year abuse he flagrantly dishonours his wife and her desires.

The drama's opening on a dream is especially significant. Fictions normally open with the physical setting in which the action will proceed. By opening *Shtisel* with a dream the writers impute equal reality to the various levels of existence this highly spiritual work portrays: dreams, memories, visits from the dead, artistic intuitions, etc.

These open into the wider imagination that this fiction addresses to its audience. The closing scene in Season One — the midpoint in the two-season structure — presents the characters' lives as a drama that Malka and her dead husband are watching — as we are — on television. The medium that this Haredi community forbids on earth has celestial acceptance. Arguably the drama's most compelling theme is the peril of allowing religious dictate — or by extension, any other form of authoritarianism, especially the ubiquitous patriarchal — to overrule compassion and humanity.

To some, of course, our own lives may be as insubstantial as those we watch in a fiction. Our "real life" may well be but a dream, from which we will awaken into our truer existence within God.

Significantly, the first two key romances both culminate in synagogues that are no longer in ceremonial use. Ruchami meets — and courts — Hanina in one abandoned synagogue, where he modestly lives and studies. Akiva and Libbi ultimately connect in the medieval synagogue that has been recreated in the National Museum. That is, love prospers in spaces where a religious spirit has survived the rituals.

On the other hand, the dramatists' exposure of the perils in religious restriction is balanced by respect for faith. Indeed throughout the fiction what happens to the characters is presented in ways that allow for divine intervention. Lippe's temptation, his flight from his family, his return, all may be prompted by some larger design — even beyond the playwrights' ?— than by his own impulses. When Giti aborts her abortion plan upon hearing of Malka's coma — is that accident or a divine prompt? The writers allow us our choice. So, too, the sexual realization of Ruchami's marriage to Hanina is left entirely undeclared. The resumption of her parents' intimacy is also left to our surmise — until the unwanted pregnancy prompts the abortion plan.

Consistently the writers leave their plot open to allow responses of significantly different religious views. Does the salty Rebbitzen really kill herself? She has the pills. She prevents Malka's religiously required intervention. She appears to die as we are directed away from her onto the TV news program (II,4). But as no funeral is mentioned and we don't hear of her again, those viewers who would reject the dignity of suicide can contend she didn't. They can also ignore the evidence that suggests Malka finally took her own life as well, with the pills she kept from her friend, and returned to nature as the very first episode suggested is the Eskimo elders' honour.

Like the best fictions this drama provides a circumspect examination of its themes, yet allows the reader to make the moral choices. One has learned to expect this complexity of plays like *The*

Merchant of Venice and *Othello*. Rare to find it on television. Bear this in mind when you approach the season's very last shot.

<div style="text-align:center">Episode One: White Flags</div>

Nothing in the third season's opening scene suggests it is anything but a moment in the characters' life. After a close-up on blue-grey paint — the sole reminder of Shulem's over-painting his dead wife's hair five years ago (II,12)— we see Akiva painting his wife Libbi — and chatting with her. All their later scenes in this episode seem to be incidents in their "real," earthly (i.e., TV) lives.

But in fiction — context rules. This opening scene recalls the writers' trick in the two earlier season-opening scenes that arrestingly opened on dreams. The first was Akiva's of his dead mother Dvora. The second was Shulem's of his comatose mother Malka. We soon discover that this season also opens outside the characters' normal level of event. Here Akiva converses with his dead wife, as Elisheva visited with her two dead husbands and the fallen Shulem with Dvora.

Confirming the parallel, Akiva and Libbi now have a crying baby named Dvora.[2] Akiva goes to feed her so Libbi can hold her pose for his painting. As a father Akiva apparently follows the advice Malka gave Shulem in his dream, opening Season Two: "Look to your puppick" (navel). That is, respect your umbilical connection; honour your feminine side. Akiva has consistently shown his feminine sensitivity: in the spiritual nature of his art, in his cooking (for Elisheva as well as for Shulem), indeed in the delicacy of his very bearing.

Libbi wishes she could breast-feed baby Dvora, "if only once." Why can't she? After all, we remember young Ruchami's pretend breastfeed (I,3). So if Libbi can't she must be dead. Akiva alone hauls the baby's carriage up the stairs to Shulem's home. At his exhibition

2 The charming baby girl is portrayed by twin brothers, Ari and Levy, family name protected. I understand this was their film/tv debut.

opening Kaufman confirms that Libbi has been dead for eight months. That's why Shulem urged Akiva to get over his grief and face the responsibilities of fatherhood.

The phantom Libbi supports Shulem's advice. She urges Akiva to sell the portraits. Their debate recalls Akiva's conflict with Shulem. For Akiva art is a reach beyond the material world into the spiritual, the eternal. For all his religiosity, Shulem cannot see beyond the material. He considers art a poor refuge for those who lack the Torah. Here Akiva begs Libbi not to let him sell her portraits: "They're us. They're you…. No, it's not just oil on canvas. It's all there is." To Libbi's "Life is short, you know," Akiva responds "Life is endless." Art — like that other approach to spirituality, organized religion — aims for that immortality.

As Akiva remembers their wedding night, he unclasps Libbi's wedding gown. Before any flash of flesh he suddenly stops and goes for his easel. He pauses the wedding night to sketch her. "Do you want to live too? Or just draw?" she asks. "They're the same."

In his exhibition that bridal portrait is the first sale. It will loom across the season. Loathe to commodify his emotion, Akiva at first rejects the money but dealer Kaufman insists.[3] Ironically, Akiva's obsessive grip by/on his art substantiates Libbi's fear when she initially made his abandonment of art a condition for their marrying.

The episode's various plot threads demonstrate Akiva's memory of his mother's observation: "The greatest danger is feeling no-one cares for you." This countered Shulem's colder principle — letting the babies cry so as not to spoil them.

Akiva's art embodies his and Libbi's mutual devotion. Hence his need for her posthumous visits — in his studio and in the cab that takes him to the Kaufman show of his 18 memorial portraits. Shulem and Giti don't know about this important show. But Libbi is there to calm his nerves. For reality, once as Akiva paints he studies Libbi's empty chair.

3 The name Kaufman, incidentally, includes the yiddish "buy," "kauf."

In contrast to Akiva's imagination, Ruchami is frustrated in motherhood. She is working for Shulem, headmaster ("Spiritual Manager") of his *cheder* (school), who pointedly wishes her soon to have "maternity leave." While Akiva is visited by his dead wife, Ruchami's husband Hanina is the most notable absence in the first episode. Instead the romantic drama shifts to two other stories, one forward, one retrospective.

In the forward plot, matchmaker Menucha wants to arrange a marriage for Giti and Lippe's 19-year-old son Yosa'le, in his first year of Yeshiva study. Menucha counsels despatch because the Lippe scandal still hovers over the family. An early marriage to the daughter of wallpaper merchant Levinson is advisable, if only as a covering. Yosa'le wants to wait until his fifth year but the yeshiva head assures him he could handle both marriage and study.

The first date reminds us how different the Haredi community is from its surrounding world. As Yosa'le enters the hotel he passes a stylish secular couple — with a mini dress. Yosa'le doesn't notice. Later Menucha jokes about how a yeshiva boy could describe a girl.

Confirming this insularity, when Yosa'le goes to meet his arranged date, Shira Levinson, he instead meets one Shira Levi, who has been waiting for a different Yosa'le.[4] With the wrong Shira he finds immediate comfort, attraction and — he soon claims — love. "We had an amazing connection." The Levi name echoes the what-might-have-been in Akiva's friend Levi Itzhak and then the less Orthodox artist Hadassah Levi.

When they accidentally meet later, their connection banned with lies on both sides, Yosa'le writes his yeshiva phone number on Shira's hand. Her fingers relax and open under the comfort of Yosa'le's writing. The signature portends their relationship: "It's a little crooked but you

4 In the next episode, Hanina at the yeshiva will read of a succession of historic Yossis.

can make it out." They are a charming couple. On their mistaken date Shira admires his singing voice.Yosa'le gallantly accepts her: "Describing oneself as a scaredy-cat takes a lot of courage." This when she admits she likes to travel alone, especially into the Ramot forest whenever she feels fear.

As authoritarian as her father, Giti rejects her son's romance as angrily as she did Ruchami's. She hardens all the more when Lippe reports the girl is an Algerian Jew. The family is Jewish, orthodox, with distinguished scholars, and they will give the couple an apartment. Indeed the Levi home and the parents' dress and manner suggest they are of higher class than the Weisses. But they're Mizrachi, which prompts the Ashkenazi Giti's rejection. Pragmatic Lippe reduces this difference to culinary: "They just like their fish spicier than we." In fact, two episodes later Giti will recall that her grandfather loved his goulash red and spicy. Giti sustains her father's presumption of superiority..

Lippe defends Yosa'le's love as he did Ruchami's, but again caves to Giti. He even lies to Yosa'le, as he did to Hanina, about the girl's availability. So, too, his pragmatic advice to Yosa'le: "The fewer girls you meet the fewer you'll have to compare them with, the happier you'll be."

In the retroactive romance, Shulem's brother-in-law Sucher Issacher meets and becomes engaged to Nechama, the fiancee he abandoned 50 years ago. "Just when you thought you'd seen everything a Jew can see," Shulem marvels, a miracle like this occurs. "A gift from the heavens," he concludes, when he hears of their accidental re-meeting, their engagement — and Nechama's winning 3,000,000 shekels on the lottery ticket Sucher sold her.

We've seen (I,5) the harsh consequences of Sucher's flight from his community. This happy accident seems to bear out his earlier joke about his religious function: buying lottery tickets is like praying with notes left in the Wailing Wall. Even as he toasts the lovers Shulem plans to solicit a donation: he immediately intuits that Nechama "has the air

of a *nogida*," *i.e.*, a wealthy, generous woman. She develops into one of the drama's most admirable characters, living up to her name's connotation of comfort, solace.[5]

Their re-engagement after 50 years seems a miraculous redemption. It grows out of Shulem's confused quip about God's and man's plans proving tellingly different. After all Sucher has suffered since fleeing his strict community, this redemption could justify the community's trust in God. Or not. It could be accidental — or dramatic irony. But hard upon this apparent blessing — Sucher dies. Both in the romance and in the demise we are free to read God's hand, social forces — or neither. Typically, this drama neither confirms nor denies a divine order in our lives. It does allow for it.

Shulem remains selfish. As he invites Akiva to move in with him he pauses: "Dvoraleh doesn't cry anymore, does she?" When Akiva does finally move in Shulem awakens the baby with his indignant "Who shushes a Jew in his own home?"

As usual, the learning that Shulem inflicts upon his family proves shaky. Refusing to lend Akiva rent money to avoid eviction, Shulem explains: "I can give you money but I'd rather give you fish. A fishing rod." He fumbles the adage that a gift of money may provide one meal but providing a fishing rod, many. Then he garbles another: "If life gives you lemonade take it!" That is in response to Akiva's refusal to sell his Libbi portraits. Akiva considers them the sustaining honey in his life, not the lemons.

Shulem incurs disaster when he violently slaps a school choirboy's face for mischief. He dismisses the stunned class with "Go think about what you did wrong" — oblivious to his own transgression. The scene recalls Shulem's slapping Akiva when he passed his anger off as a teaching lesson (I,2).

[5] I am grateful to my friend Rabbi Lynn Greenhough at Kolot Mayim, Victoria, for name meanings, *inter alia*.

This time a student publishes the school incident on the internet. The victim's family threaten to report Shulem to the police. Board members stave them off but Rabbi Weinbach insists Shulem announce his immediate retirement, at his speech at the school fundraiser.

With his usual patriarchal authority, Shulem defends the teacher's right to slap wayward students. And the headmaster's right even more so. But "the times have changed," Weinbach warns. With his immediate retirement Shulem could "leave with [his] dignity intact." They could even release rumours of a mysterious illness.

At first Shulem appears to accept this. Then he phones Weinbach in full grovel. He accepts the ban against physical abuse, but begs to stay on. When Weinbach holds firm Shulem appears resigned to departing.

But at the fund-raiser Shulem declares himself victim of false report. The episode's title comes from his declared refusal to wave "the white flag" by which losers in war customarily surrender to the winner. Hijacking the school's fundraising program, he calls for donations to his own new school, to be funded by Nechama's large donation in memory of her beloved Sucher. As if to justify his misconduct, Shulem pledges his new school will revive "the purity of the good old way." Shulem proves as selfish and self-debasing here as when he promoted himself at Akiva's award ceremony (II,5). When the aged board members rush him off the stage and start up the choir Shulem's dignity is in shreds.

Episode Two: The Bird

If the first episode updates us on the characters' situations, the second resumes the more sophisticated strategy of devoting separate plot lines to one central theme. As stated by Shulem, the theme here is despair.

In the religious context, faith might preclude despair. As Shulem considers his loss of his school, job and status: "I'm not sure that there is no such thing as despair. It's not written anywhere." He suggests that

perhaps some despair might solve some of the world's problems. But when his chicanery succeeds he resumes his faith, singing: "Rabbi Nachman of Breslov used to say, there is no despair. There is no despair, never despair. There is only joy." In three plot-lines the family faces despair but salvages grounds for hope.

Shulem is driven to despair when even his self-abasing campaign to attract students fails to produce more than 11 includes Zvi Arye's sons. But far from the existential despair of theology this is Shulem's vanity. He denies responsibility for abusing his students. His enrolment campaign intensifies his former school's antagonism. Weinbach delivers a formal injunction and promises legal action.

An early scene summarizes Shulem's failure as the family patriarch as well as the school's. To Ruchami's regret that Hanina's studies leave her usually eating alone, Shulem says "What's there to talk about?" Ruchami should consider herself lucky to have a husband so completely dedicated to Torah studies. When Zvi Arye jokes about his father not remembering his kids' birthdays Shulem angrily hangs up on him — even though his son is providing Shulem's first enrolments.

In yet another display of his garbled "learning," Shulem excuses his aggressive campaign for students: "If the mouse won't come to the Rabbi, the mountain will go to Mohammad." This is hardly the solid knowledge expected of a *cheder* headmaster. Rather, it reminds us how weak Shulem's claim to authority usually proves to be. He assaults learning as well as students.

Shulem's despair deepens when Nechama rejects his circumlocutory marriage proposal. His ego is wounded when she says she so loved Sucher she could never love or wed another. As he did when the much younger Adi rejected his proposal, (I,10) Shulem flees their coffee date immediately. Selfish, he has no patience for niceties and form. If a relationship — or date — is not on his terms he leaves.

Shulem shows that wound when he rants at the school governors: "I'm no modern orthodox lottery ticket salesman!" The

"lottery salesman" was Sucher. When a crowd of protesters rail outside his window — "Rebellious Elder!" — Shulem draws on that wound to recover his resolve. Nechama's rejection echoes in his explanation of the protesters: "People always want what they can't have…. If you can't have her you want her more."

That inspires Shulem's new strategy. He despatches Zvi Arye to join the protesters — with yet another error. Zvi Arye is good at singing. But can he also "actate"? The error will prove moral as well as grammatical.

Zvi Arye joins the protest chanting "Shame on you, Shtisel. " He says Shulem rejected his own grandsons' applications to his school. "The new *cheder* is only for aces, not mediocre students." By appealing to the parents' vanity, Shulem deflates the protest. He makes his Old School harshness a virtue.

Now the fathers line up in proud hopes that their sons will pass Shulem's supposedly tough admission test. They have been conned into subordinating principle to vanity. Of course the test isn't hard. The "trick question" is just a straightforward Biblical memory test. Even Shulem's fraud is dishonest.

The tables (or the worm) having turned, Weinbach rushes to save his *cheder* by reinstating obsolete Shulem as headmaster. Shulem's vanity has compromised his school's integrity. His happy ending is a sad result for the school and the society.

As he no longer needs Nechama's money Shulem phones to take his formal leave from her — as he broke his engagement to Menucha by phone. The homonymy of the two widows' names invites our comparison of their characters, the matchmaker scheming and self-serving, Nechama selfless, honest and cultured.

Now Shulem can forget Nechama's proposal to promote her beloved Sucher's love of modern poetry — not the more traditional "bards" Shulem favours. By the way, his Reb Yom Tov Erlich (translation: holiday honest) may remind us of Shulem's tendency to invent people for his own purposes, of which his Yocheved Gesundheit

(II,12) was the most destructive example. But that Hasidic musician actually lived (1914-90). As usual, truth is more ironic than fiction.

This episode opens on a dream, like the alternative reality that opened the first two seasons. Here Akiva pounds on a window that keeps him from his wedding portrait of Libbi. Her face dissolves into darkness. In despair at having sold his paintings of her, Akiva is driven to drink — even sleeping through his care for Dvoraleh. His obsession equates the painting with his lost wife: "I shouldn't have sold her.... I'll do whatever it takes to get my wife back." This equation is as irrational as Shulem's indignation (II,12). Akiva confuses the model and the painting.

Bent upon recovering his sold work, Akiva rejects Kaufman's substantial payment — and his sensible advice: "Here. Make a new life for yourself." Akiva physically forces him to identify the buyer of the wedding portrait — and two other Libbis. "Please, be polite," Kaufman urges, "Be a gentleman. Be a *mentsch.*" The "gentleman" prepares us for the surprise: the buyer turns out to be a woman, Racheli Varburg, not Kaufman's earlier "he."

Racheli is a variation on Hadassah Levi (II,8), the modern Orthodox Jewish woman whose religion accommodates some secular pleasures, especially art. Where Hadassah made art, Racheli buys it, knowledgeably, as investment for her family's trust company. Akiva coaxes her into letting him replace her three Libbi portraits with three new works — of equivalent value.

But the three paintings he brings her are still lifes, significantly smaller and clearly tossed off without his distinctive commitment. When Racheli properly rejects the exchange Akiva is furious: "Just give me back my wife. Give me back my paintings." Surprisingly mean, Akiva leaves with a harsh personal attack: "You are a cold person with a cold heart.... I can tell you are lonely and I know why too." This is a severely diminished Akiva — weak, cruel, indulging in drink and rage.

Racheli defends her rejection. These works don't have "an ounce of the heart and talent" of his Libbi paintings. We saw how mechanically Akiva approached this work: "Painting No. One." It was a chore not a drive. The result was the kind of work the con "artist" Fuchs paid him to churn out (I,4). Left teary-eyed by his insults, Racheli still invites him to bring her a more serious effort.

But perhaps Racheli has touched him. She has respected his integrity by requiring genuinely felt works. With a yeshiva boy's lesson by parable, she cites the circus job applicant who seems an ordinary bird impersonator — but he can fly. She wants Akiva paintings that show him in full flight. Hence "The Bird" as the episode's title.

Akiva may unconsciously acknowledge Racheli's reminder of his calling. We last see him idly sketching the head of the woman whom he just excoriated. She has touched a nerve. Catching himself, he crumples the drawing and tosses it. As an augur of a possible relationship, Racheli bears a strong resemblance to Yosa'le's wrong (*i.e.*, right) Shira. In addition to wearing glasses, they are similar in height, hair, face, bearing, intensity. Both stave off fear.

<p style="text-align:center">***</p>

The younger marriage has its own impasse. To celebrate their fifth anniversary, Hanina comes home surprisingly early to eat. His total devotion to religious studies is not an unmitigated blessing for Ruchami, who usually eats alone. Hanina bears out Shulem's "What's there to talk about?" (III,1). The couple's issue cannot be addressed by Hanina's *Talmud* quotations: "Enough with that verse!" Ruchami is less excited than he expected by his anniversary gift — a text: "At the well's mouth, A new exegesis for the love of Jacob and Rachel and the removal of the stone." That does not address their problem.

Their stone is that Ruchami has a serious physical condition that could make bearing a child fatal. The unexplained death of young mother Libbi casts a tacit shadow across Ruchami. An obvious recourse — a birth surrogacy — is forbidden in the Torah. In consulting with the yeshiva headmaster Hanina struggles even to name the procedure.

As Ruchami is willing to risk her life to have a child, she asks her doctor, Professor Mishnayot, to remove her IUD. In this patriarchal order, the doctor betrays the wife's secret to the husband. So Hanina — "knowing my wife" — predicts her dangerous gamble.

When Hanina seeks his rabbi's approval of a surrogate pregnancy he receives something rare in a theocracy: compassion overrides religious dictate. "You are now in a position where the Torah does not exist outside of you. It's your flesh and blood. Therefore, any decision you will make will be in itself Torah guidance." The headmaster acknowledges religious law but allows variance to serve Hanina's "non-ideal" situation. That's a huge step away from the yeshiva head who five years ago expelled Yosa'le for harbouring a stray dog (II,11). The headmaster's respect for the "flesh and blood" over the abstract law parallels Racheli's demand of Akiva's art. Both prefer humanity over form.

Where these authorities accord privilege to another, Shulem arrogates to himself full authority over his school. Because he gave his heart, soul and tobacco-stained lungs to that school he claims to own it. "If I trespass I trespass only on my property!" In Yosa'le's interview the yeshiva headmaster makes a humane decision in placing the human concern over the institutional teaching. But Shulem improperly assumes this right for himself, to rationalize his self-service. Shulem argument is a corrupt parody of the headmaster's reasonableness.

When Hanina agrees to the surrogacy — however expensive — Ruchami prepares to wear a succession of stomach pillows. "No-one needs to know you didn't give birth to the child." This "playing" or "performance" of pregnancy recalls the younger Ruchami "performing" a false nursing to calm her crying infant brother (I,3). This personal performance of a larger form evokes the communal rituals performed in religious practice. Hanina's concealment of the surrogacy is religious discretion — and vanity.

Of the three central Shtisels here, Ruchami has the greatest self-awareness — and expressiveness. Recalling her having read secular

classics (*Middlemarch, Anna Karenina*), Ruchami pulls a secret stash of notebooks out from under her bed. She starts writing "Letters to my beloved little girl I will never give birth to." In the first she describes the piercing black hole she feels inside her: "This hole inside me is shaped like you." God willing, she will have that baby, through a surrogate. But already in Ruchami's mind, her absent daughter is a presence.

As Ruchami converses and lives with her daughter before her birth, Libbi lingers in Akiva after her death. She remains a presence to be felt, conversed with, painted. Ruchami's letters and his paintings express hope and love in the face of despair. Ruchami's letter to her daughter-to-be is intercut with two Akiva scenes. In one he cuddles his baby daughter, shadowed by the lost mother's portrait. In the other he sketches Racheli's head, an unconscious augur of a mother-to-be?

In all three cases the Shtisel family member is tempted to despair at a challenge apparently beyond solution. Though Shulem vainly cites faith as his buttress against it, in all three cases the solutions depend on the characters' flexibility, will and ingenuity, not on any divine intervention. Their devotion is to the human. For all the religious context in the Shulem and Ruchami threads, they succeed through wholly secular initiatives. For them, the Lord truly does help those who help themselves.

In Akiva the confusion between the painting and the subject confirms that art is an alternative spirituality to religion. Akiva's equating the subject and the object, the spirit and the thing, is a kind of idolatry. By equating painting with wife, he desires a material immortality beyond art's power to deliver. That desire can only lead to frustration, anger and despair. In both faiths, art and *shule*, the only possible immortality is the spiritual.

Episode Three: Public Telephone

In one of this drama's most pivotal scenes, Giti at work opens up to an old friend, Malki. They haven't met since five Chaya Greenberg kids ago. Malki's husband suddenly abandoned his family. The women's exchange, as it moves between misery and laughter, encapsulates what's arguably the central theme of *Shtisel* — abusive authority in the patriarchy. This is what makes this story of an ultra-orthodox Jewish community universal in its insight and appeal.

"It's amazing," says Malki, describing the radio talk shows to which her sleepless nights have turned her. "They're just like us…. The non-religious women. Those pathetic women who forgive everything, accept everything the men dish out…." "And then give thanks to God," adds Giti. Both women laugh freely, in this rare moment of sisterhood. "Exactly," adds Malki, "And feel guilty that they don't find it tasty."

The women's quiet intimacy contrasts to the later rowdiness when the uniform men drunkenly celebrate Yosa'le's engagement. The men's exploitative power also lies behind their ribald joke. The concept of a *shabbos goy* — the Gentile hired to perform the small duties a Jew is not permitted to do on the sabbath — makes a serving woman a weekday Jew.

This theme also sounds in Yosa'le's apparently free-standing remark at the yeshiva: "Suffice it that the doors are fit to be locked even if they are not actually locked." The rules control even when not enforced. In a legal structure, a power system, a social institution, the limits are effective just by their presence, even when they may not be activated. For Malki and Giti, whatever powers they may assert they remain delimited by the patriarchal rules in place. The women's emergence from suppression here recalls Shulem's vain theory of male supremacy and his personal eclipse and exposure (I,7).

This scene represents a significant growth for Giti. When Malki first came for advice Giti denied Lippe's desertion: "Nothing like that

ever happened to us. I have to get back to work." By her reflex denial of the truth she failed to give a desperate woman the support she needed.

Giti takes Malki's next appearance as an opportunity to apologize, to admit the truth (finally) and to offer help. For short-term support Giti offers her a job, sensitively: "I need help in the restaurant." The episode's title cites the range of private conversations across all the plot-lines and — in Giti's initial tension with Malki — protecting her secret from public knowledge.

Less usefully, Giti bases her advice on her own experience, certain that "People worry for nothing. It all works out in the end." She counsels Malki not to reveal the truth to anyone, not to her children, her parents, no-one. This would facilitate what Giti is certain will occur: the wayward husband's return. "They always do." But now Malki does not want him back. "For the first time in a long time I know what I don't want. That's something, isn't it?"

As if to support Malki's doubts, Giti's relationship with the prodigal Lippe remains a battle of wills — and subterfuge. Both work hard at their family restaurant. Lippe tries to get the film set to order Glatt Kosher food for the entire cast and crew, not just the marginalized extras. "No way I'd serve it to my actors," Odelia remarks, but will taste his. When he praises his chef wife Odelia calls him "a sweet husband."

Lippe is offered a walk-on role but Giti refuses permission. His appearance on a TV show would only further imperil Yosa'le's marriage hopes. Lippe lies about his response and proceeds. He ruins his scene—then abandons the filming — when Giti calls to report the match with Shira Levinson. Lippe even takes pictures on his smart phone, which he has because "I'm not up for Minister of Torah." This worldliness makes Lippe more sympathetic to their son — though not yet to confront Giti.

Her determination to marry Yosa'le off increases when Malki reveals public knowledge of Lippe's abandonment. Lippe resists her urging him to push his son, worried at the pace of Menucha and Giti promoting the *shidduch*. Even at the engagement celebration Lippe tells

Yosa'le "As long as you're sure this is what you really want." Giti shows no such respect for her son's desires.

Yosa'le may want this Shira — until he hears the other one on the phone. On their first date he immediately finds the proposed Shira "a special girl," with a warm heart ("the most important thing") and a compatible sense of humour. She asks God to extend her ailing father's life by giving him some of her years. She laughs at Yosa'le's explanation of their missed first date, relieved that he hadn't "freaked out and run" at the sight of her

When she says she'd been told he'd been kept away by illness Yosa'le wonders "I don't know why people don't tell the truth. Why is it so hard?" This is the idealistic Yosa'le who confronted Ruchami over her *Hannah Karenina* lies (I,11). In contrast to his first "Shira" date, on entering the lobby he passes a more conservatively dressed couple. On this date the order seems restored.

But the "wrong" Shira has some magic — their accidental meeting, their instant attraction. That mystery deepens when she phones him at the yeshiva and hangs up at his voice. Yosa'le finds this distracting but intriguing, especially since he is such "a straight arrow," as friend Feivel notes: "This sounds like something messed up guys would do."

Perhaps Yosa'le is no more a straight arrow than Lippe is. He is his father's son, certainly in heart and possibly in needing to stretch his limits. As Lippe won Giti's heart by privately giving the doorman his own gloves in the cold, Yosa'le still has the compassion and generosity he showed when he sheltered the stray dog (II,11). The intended Shira may be just fine, but the accidental Shira may be the Intended, *bashert.*

When she and Yosa'le finally do talk, they are impeded by the formal courtship process. Again, religious regulations impede a human connection. She "was afraid to talk." "I can't really talk to you," Yosa'le replies, "I'm engaged." The scene recalls Elisheva's farewell call to Akiva (I,3), having heard of his engagement to Esti. But this Shira

didn't know of the engagement. Yosa'le doesn't run after her. He sits, disturbed, wondering if he's getting the right Shira.

<p style="text-align:center">***</p>

Giti's change from denying her experience to constructively sharing it points to a larger theme — growth from experience. Shulem proves a newly benign principal when he lets a boy keep his electronic game-player, assured it won't access the dread internet. "Games are a nice thing," says the new softie. He has advanced from the violence that threatened his position.

Unfortunately, this temperance does not hold. When he stops Nuchem from jumping from the balcony Shulem erupts in a rage at the "spoiled little child" who was their parents' favourite and who left his garbage for them to pick up. This outburst nullifies Shulem's attempt to persuade the Welfare Department agent Yisca that baby Dvora is indeed safe and well cared for.

Akiva is under "parental performance investigation" as a result of neighbours' complaints, Akiva's alcoholism and Farshlufen's taking away the wrong baby and stroller on the drunk Akiva's behalf. Now Yisca sees that of the two resident grandfathers, one has just attempted suicide and the other is given to violent rage. Nor is she reassured by Akiva's "It's nothing. It's my uncle. He's Dvoraleh's grandfather too." Akiva next learns that a social worker and a policewoman have taken Dvoraleh to a shelter.

Akiva's growth is evidenced when he returns to Racheli with a new painting. Immediately grasping its power and integrity, she returns the wedding portrait in exchange. As the much smaller painting seems of less than equivalent value, Racheli scores points for humanity.

Akiva's painting of Nuchem passed out on the couch recalls his sketch of a sleeping Shulem, the work that won him Kaufman's support (II,2). There he painted as powerless and vulnerable the man who had just fired him from his teaching job and demanded a written apology. After making the painting Akiva tore up his letter, released from his father's authority. In the broken, sleeping Nuchem Akiva again depicts

the vulnerability of an oppressive power. This man had forbidden him from contacting Libbi. In both paintings Akiva exposes the oppressive patriarch's weakness He finds in art the solace, illumination and expansion his father finds in religion.

As Racheli reminded him, Akiva's response to people has a power missing from his routine still lifes. This theme arises in the yeshiva: "We don't look at the object. We look at the man." Moreover, in both male portraits Akiva intensely individuates his subject, all the more remarkable in a society that so stresses uniformity. Their distinctive character sets them equally apart from the imitation rabbis he also used to paint for Fuchs (I,4).

In a comic version of rooting art in the human reality, Lippe ridicules the TV actor's obviously glued-on beard, the Orthodox characters portrayed by "yeshiva dropouts" and an actor's yiddish that sounds like Czech. Of course, that is far from the *Shtisel* standard in TV production. When the fake-beard actor playing Lippe claims a more genuine beard than the inner-TV show actor wears, we have a spectrum of realities, from the most material to the most spiritual. All are equally true, equally fictional.

In contrast to these characters' growth, Nuchem's unexplained loss of his wife and daughter have broken him. Shulem retrieves him from a synagogue where he has been sleeping, not eating, evincing suicidal despair. The gregarious fraud is speechless stone. After Shulem saves and berates him Nuchem cowers, whimpering.

As an emblem of the human condition Nuchem recalls the episode's opening scene, where — anent Farshlufen and Akiva — there's a thin line between the "loopy" and the "bum." Farshlufen sees a pitiable nebbish in what he thinks is a window — but it's a dirty mirror. The drinking lads joke about their identity. In fact, Farshlufen has been getting a new ID card every week because he's interested in a girl at the Internal Bureau. However malleable he may hope his identity is, we can't have much hope for his chances.

Another summary of the human condition appears in Yosa'le's date at the Natural History Museum. He finds humanity in the natural world, as the stuffed bear is "waiting for the Messiah." The exchange over the beautiful butterflies replays the constant tension between our physical and spiritual levels of existence. It recalls Akiva countering Libbi's "Life is short" with the artist's "Life is endless" (III,1). The butterfly's brief — one-day — lifespan is mitigated by the eternal life it is accorded in the museum. There its life-record preserves it and prevents its decay into dust.

This scarching episode marks the one-third point in the season's structure.

Episode Four: First Smile

Three interwoven plot-lines are advanced by subterfuge, even dishonesty — but for good reason. Even a rigid orthodoxy allows for situational ethics. As is central to this drama, the needs of humanity should overrule religious/legal dictates. That all three dominant agents here are women supports the reduction of patriarchal authority. Two of the subterfuges are dramatic, but the one most subtle may have the most dramatic implications.

The most dramatic is Ruchami's lie to Hanina that it is too late for them to withdraw from their surrogate baby commitment. Ruchami senses Hanina's lack of engagement. Meeting with the social worker Avigail, Ruchami has to snap him out of his religious study. He refuses to meet the woman who will bear their baby, for a lame excuse: "The fewer people that know, the better." The surrogate mother will know. As Ruchami explains her anger, "I was hurt because it felt that you don't see me."

Forced to talk, Hanina admits feeling guilty that their surrogacy violates the Torah — despite the head rabbi's permission. Ruchami's

plan to remove her IUD left him in the "forced compromise" of surrogacy. She, of course, is appalled that her (male) doctor betrayed her confidence by telling him. She leaves Jerusalem to have her IUD removed secretly.

Though Ruchami does phone Avigail to cancel, she lies when she tells Hanina the surrogate's pregnancy precludes cancellation. With this ploy and her IUD removal Ruchami risks her life to give Hanina a child without compromising his faith. This though — having talked it through — he accepts the surrogacy. That pretence leaves Giti ecstatic: "I couldn't imagine you not having children.... I would die if I thought you were having a child yourself" — because of Ruchami's dangerous condition.

When she tests one of the fake rubber tummies Hanina is struck by her radiance: "Don't take it off. You're beautiful that way. Can I hug you like this?" As Ruchami "plays" at being pregnant she echoes her earlier pretence to nurse her infant brother (I,3). She also pretended to parenthood when she wrote her brothers assuring letters in their absent father's name. Ruchami again commits a principled falsehood.

<div align="center">***</div>

Slightly less dramatic is Racheli's gaming of government welfare when she offers to marry Akiva, so he can recover his infant daughter. Racheli is immediately sensitive to his danger: "What incident? They took Dvoraleh?" She understands the Decision Committee's concerns — "It makes more sense if there's a mother in the picture." "But there is no mother," Akiva responds — except in his pictures. Racheli's "in the picture" collects the tensions around Akiva needing his paintings of Libbi because he lost Libbi. A motherhood painting hangs soft-focus behind him during that exchange.

Akiva asks Racheli for a letter confirming he is working for her as an artist, on salary. "You're asking me to lie. I can't do that." When Akiva returns, he desperately offers her all his exhibition paintings in return for that letter. He will lose his Libbis to secure their daughter.

This scene opens with Racheli lying on her sofa. Though she suggests she is not feeling well, we later learn her condition is mental. Hence her dramatic shift from denying the requested letter: "All right. I'll do it for you…and Dvoraleh. I'll marry you…. She's precious to me. For your daughter and her mother. Some things are worth lying for." That she skillfully does when she gives the Decision Committee a plausible explanation for the baby's earlier abandonment at daycare. The baby once secured, Racheli declares, the newlyweds will divorce and part ways.

For their wedding ceremony Racheli appears radiant in a white dress: "You only get married once." Otherwise the event is bare of romance. The officiating rabbi, the clerk's father, has an ear infection and refers to Shulem as Sholom. The clerk sends Racheli — in her gown —to check whether there's enough paper in the printer to run off the document. The ceremony has witnesses as perfunctory as Sucher's burial. Nuchem attends under physical threat from Shulem should he breathe any opposition to the wedding so soon after his daughter's death ("You've done enough damage to the people of Israel").

As the couple procure their wedding certificate the clerk several times repeats the phrase "Walk humbly." The full statement — from prophet Micah: "Love justice, do mercy, walk humbly with your God."[6]— prescribes humility in a respectful marriage. Here it's quite redundant, especially given Racheli's selflessness in helping Akiva recover his daughter.

The Decision Committee responds to the news of Akiva's marriage with — "Well, this changes the picture." That is literally true. Racheli presents *the image* of a marriage, not the reality. The wife's job as Vice President of Investments in the family's firm ("mainly in New

[6] As Facebook friend Chris Maylor suggests: "Walk humbly" is the secret to a long and happy marriage. Marriage is *Adonai*'s gift, and the *huppah* is the reminder of this, so that neither husband nor wife will exalt themselves above the other. Shulem and Zvi Arye fall short.

York but also in Israel") doesn't hurt Akiva's cause. Nor does the two grandfathers' absence. Akiva's success contrasts to the case before him, which ended with a man stomping out in a swearing rage. Obviously he didn't have a woman to help his case.

<div align="center">***</div>

In the episode's subtlest manipulation, Nechama phones to remind Shulem of Sucher's memorial. She intends to reconsider his proposal. Having lost Sucher she finds loneliness "twice as hard" to bear than before they renewed their relationship.

Though Shulem initially says his family issues prevent his attendance, he comes — and tips the attendees. He is moved to (hidden) tears when Nechama recalls Sucher telling her "Poetry is the marrow of life," then reads aloud Nathan Alterman's poem, "First Smile." That gravesite choice confirms the equation of art and religion as alternative approaches to spirituality. The poem moves from mortality —

> Do not call me me with many words.
> Everything shrivels and dies.

— to a rebirth in love:

> Yes! Sometimes your memory
> Will seize me suddenly….
> With a tempestuous fury
> With broken-winged happiness.

Still resenting her rejection, Shulem doesn't address Nechama by her first name. He claims to have forgotten his proposal, then dismisses it as aberrant, something "far-fetched" — "supposedly I suggested that supposedly you and I…." Then he scales down her dinner suggestion to a 4:15 coffee and cake date, with the cheesecake "I grew up on," Brizel's, unchanged in 50 years. The old patriarch prefers the unchanged even in cheesecake.

Nechama's plot-thread opens with her radio job. She introduces a recording of Tchaikovsky's symphony, *Le pathetique*. As she explains, the title does not mean the apparent 'pathetic' — pitiful, ridiculous —

but promises a range of pathos, of tempestuous emotion. That coheres with the Alterman poem and Akiva's request of Racheli.

But the music returns more functional when Shulem is snoring through his cheesecake date with her. Hearing Nechama hum that music snaps comatose Nuchem back to life (as his visit did his mother in II,1). We glimpsed his love of music in II,10. Here Nuchem joins Nechama to recover his lost spirit. He offers her a soda. When she finds him "more of a gentleman" than brother Shulem, Nuchem is fully restored: "Shulem a gentleman? Like a donkey making pancakes."

He has also recovered his selfish aggression. When Nechama introduces *The Kreutzer Sonata* on air, Nucham in the recording booth overrules the director's instruction for her to stop talking. So she continues, to describe the "entangled triangle" at the heart of the novel Tolstoy based on the piece. Having lost again, Shulem denies his triangular relationship with Nechama and Nuchem. He disdains them as "Two miserable souls. They'll help each other." He ridicules his brother's emotional revival: "One day he wants to die, then he finds himself a Royzelleh." In the name may unwittingly lurk Romeo's Rosalind, so soon forgot.

The homonymy of the lovers' names supports their newfound harmony. Nechama's and Nuchem's love of classical music provides a connection of which Shulem is incapable. He completely lacks the solace and comfort she provides, in behaviour as in name. Nor dare he admit the emotional vulnerability that music evokes in his brother.

Nechama's association with culture adds a new dimension to the marginal tragedy Sucher played out earlier (I,5). Having fled his engagement, escaped the orthodoxy, served in the army — Sucher emerged a broken man. Reduced to selling lottery tickets, he wakes up screaming every night. His reunion with Nechama and our sense of her richness in love and in character expand Sucher's tragedy. In this Nechama we glimpse the life Sucher lost when he fled his community 50 years ago. As ever respectful of the orthodox community, the writers here again allow for self-realization even within such constraints.

At the same time, however, they pointedly give women the power necessary for the community's and its members' success. Ruchami has the narrowest range of authority, caught between her mother's hopes and her husband's power, but she acts to assert her will. The two women with careers, Racheli and Nechama, have more resources than the homebound Ruchami. For all three, honourable needs excuse the liberties they take with the law or with convention.

Episode 5: White

Launching the season's second half, this episode could be the weightiest in the entire epic. This TV drama confronts its own character when it cites the antagonism between the Haredi community and the film/TV industry. In effect, the episode flirts with the question whether this drama itself is pro- or anti- ultra-Orthodoxy.

Were that self-reflective existentialism not a sufficient challenge, the episode also introduces Science, the direct challenge to a faith-based cosmology. Disruptive science appears in the character of Shira Levi, whom Yosa'le mistook for his "intended" date, Shira Levinson. Science and religion conflict more seriously when Ruchami weighs her possibly fatal pregnancy.

This episode seems to center on the marital tensions in Giti's and Ruchami's marriages. Akiva is absent entirely. Shulem is only echoed in a phone call denying Lippe help with the dubious assurance: "Don't worry, Lippe. There is no despair in the world" (cp III,2). Lippe knows better: "Actually there is. I'm one big lump of despair."

The episode's central theme comes from outside these plot-lines. It involves Yosa'le's "wrong" Shira. Shira Levi is at the university in Bar Ilan, studying "genetic changes that parents pass down to their offspring due to trauma."

Though her focus is on the insect world that theme also drives the humanity here, both within the families and in the Haredi

relationship with the outside secular community. Traumatic outside changes may require changes within the family. So customs can change as genetics do. On the family level Giti's dominance in her marriage contrasts to Ruchami's submission in hers, but both are problematic. In the social order Lippe has to draw on the secular society to meet his professional undertaking.

After all, from insect to human is not that great a leap. When Shira shows Yosa'le her flies through a microscope they look Jewish. They have her grandfather's and Yosa'le's eyes — "so sad and huge." When Yosa'le notes their hill-like hair he echoes his father's requirement of the hirsute seculars hired to play ultra-Othodox extras,

Though the episode marks the ascent of the "wrong" Shira it opens on the right one, Yosa'le's "intended" match, Shira Levinson. As she helps her dying father do his morning prayers she is the perfect daughter, woman, match. In putting the *tefillin* on her father she does what normally only the men learn to do.[7] But her phone chat with Yosa'le leaves him unsettled. She didn't care to read the insect book he sent her, anonymously. So he refuses to open her gift, even/especially under Giti's command.

When he later visits her father Yosa'le's answer to his Talmudic question is correct but ominous: "Time need not be indicated in the *gett* [divorce document], so that it can't be refuted." As usual the issue drawn from the yeshiva points to a major theme. "Provisions for divorce" apply to all the plot-lines here, culminating in his request to cancel the engagement.

Yet the timing will prove important. At episode end Giti gives Yosa'le the sad news, with condolences: Shira Levinson's father just died. The funeral is tomorrow. What this means for the shaky engagement we don't know. When Yosa'le releases a fly into the

[7] As a reminder that even Spellcheck may expose a higher truth, in a Facebook comment *teffilin* was converted to Teflon.

morning light is he celebrating his own release or abandoning his devotion to the scientist and her study?

For Yosa'le the "right" Shira is the wrong one, the one he accidentally met instead of the arranged date. The "intended" Shira is not the *bashert* one, the destined, appropriate one. Here the right/wrong one congratulates him on his engagement to the wrong/right one and closes with "Good luck with. With life."

Having second thoughts, his right Shira calls him again. Thus Ruchami wooed Hanina, the girl taking indecorous initiative. When Yosa'le visits her on campus they explore their shared interests and confirm their compatibility. He is leery at her invitation to come into the lab to meet her "best friends." To his relief — and excitement — they prove to be the drosophilia flies in their test tubes.

Yosa'le gets the possibility of a way out of his engagement when the Levinson family reveal that their medical expenses leave them 100,000 shekels short on their agreement, for an apartment. Here again, the wife breaks the news that the husband won't.

But in their commitment to propriety Yosa'le's parents ignore their son's need: "I feel nothing for her. We have nothing in common. Nothing to talk about." Lippe and Giti swap positions. Formerly pushing the marriage, now Giti wants to cancel it. The previously opposed Lippe undertakes to raise the money.

When Giti rejects this change of mind, she denies history: "In our family we don't call off a match." In fact, her uncle Sucher did. Shulem claimed he did (the legendary Yochevid Gesundheit), though we have learned to doubt all his stories. Akiva happily accepted Esti's father's cancelation, to Shulem's rage.

Ever sensitive, Lippe tries to address his son's doubts. He dismisses "the seculars'" emphasis on instant "attraction" in favour of that which "builds up between a man and a woman…. All the rest is an illusion." When Giti explodes at Yosa'le Lippe intercedes: "You don't have to marry if you don't want to." At this dramatic breach between his

parents, Yosa'le cites Lippe's recollection of their respective doubts upon their engagement. Perhaps their doubts proved correct.

<p align="center">***</p>

Giti defends her own marriage when Malki reports she just got her divorce from her wayward husband. With a glance at Lippe Malki whispers "I'm sure he'll release you one day." Giti holds firm: "One more word about my husband and you won't work here."

To raise money for the Levinson marriage Lippe persuades film producer Odelia to pay him 350 shekels each for however many ultra-Orthodox extras she will need, "beards and all." Odelia is sensibly skeptical: "If you screw me I'll hate all the ultra-Orthodox." "You already do." That is a comic version of the tension between the film world and the Haredi community, soon exposed further.

Giti rejects Lippe's project with the term with which Shulem suppressed his children's ambitions: "Enough with the *fantasies*, Lippe." He's just "a kosher simple Jew, No dreams, no nonsense…. Enough with the pipe dreams." Now Lippe responds: "You never gave me a chance! All you do is snuff me out."

In the event, Giti's concerns about the film world prove prescient. "Is this what's become of you? Posting ads?" one friend asks. The obvious concern is "Is it pro- or anti- ultra-Orthodox?" In that spirit, can a candidate be filmed unseen, disguised? As for the man with neither beard nor sidelock — he's a *modern* Haredi. And the fullest response: "You from the movies? Shame on you! Stinking inciter! We'll find you and spank you! On the *tuches* [bum] and the *schwanz* [penis]." That is a violent purity. Presented in a TV drama set in the ultra-Orthodox society, this is a shimmering example of self-referentiality. The drama examines itself.

Lippe's mis-speak of "total loss" for "total look" Orthodox proves prophetic. Finding only five of the required 20 extras, he submits to Giti: "You were right again. I failed again. That's it." But she has softened, from overhearing Lippe calling out God: "Why are You always against me? You and Giti, give a man a break!"

Gitti apologizes to Lippe. She may remember why she married him, his generosity. Now she embraces him anew: "Your heart is kind, big, burning, and I keep snuffing it out. I don't want you to give up."

Accompanying him into secular Jerusalem to recruit his extras is a striking advance upon her detachment from the secular. He swears his troops to silence, not to let on that they are not ultra-Orthodox. He wants men with short hair and long beards: "Sure, we're all hipsters here." "What's a hipster?"

Another social form of genetic mutation, that's all.

When Lippe goes beyond his ultra-Orthodox community for extras to play ultra-Orthodox he moves into theatre, art, the alternative approach to his life, values and custom. Here Giti leads Lippe outside the Haredi community, to meet his needs.

<p align="center">***</p>

In the other financial crisis, Hanina's traumatic change is the bankruptcy of his yeshiva's patron. He does not want to go with his classmates to the other yeshiva. But staying where he wants would lose his support of 800 shekels per month. At first he accepts Ruchami's financial concerns: "The main thing is we decided. There is no joy like the removal of doubt." But Ruchami weakens, to accept the financial duress: "Tell him my parents are helping us. We may be hungry but we won't starve." Ruchami has bought into her husband's view: "Without something worth devoting your soul to, what's the point in living?"

That surrender brings Hanina into her bed. In the parallel scene the angry Lippe turns his back on Giti. In this sequence Yosa'le ruminates on his bed alone. Three bed scenes dramatize three stages of marital life.

Ruchami won't let Hanina take a pre-dawn yeshiva role that would pay 200 shekels a month. Instead she will secretly deliver

Independent Kosher Mail overnight for 30 shekels an hour.[8] As it happens, Hanina has already signed on for that job himself. Ruchami spies him at work but — sensitive to his pride — she hides from him.

That sensitivity is dwarfed by her other self-sacrifice. When Ruchami emerges from a bathroom puke, smiling, we infer she is pregnant. That's why she removed her IUD. She lied when she told Hanina it was too late to cancel the surrogate birth and to Giti with her claim to a surrogacy. Instead of hiding a surrogacy she's hiding a dangerous pregnancy.

Our plucky, mature, strong-willed girl submits to her husband's religious extremism. On her life-threatening pregnancy her submission is more serious than her compromise in his studies. Risking her life to give him a child may not be the choice he would make. He already protested her IUD removal. Perhaps the yeshiva head shows a more humane rigour than Ruchami when she spurns surrogacy at such risk.

In so dangerously submitting to her husband's doubts, Ruchami unwittingly confirms Hanina's yeshiva law from Episode Three: "Suffice it that the doors are fit to be locked even if they are not actually locked." In rejecting the surrogacy, she serves her husband's rule even when he has suspended it. Even in her independence she remains victim of the patriarchy.

Ruchami's predicament may explain why we're not told how Libbi (or her mother, or Sucher) died. On the Facebook chat sites Libbi's death was the Dubche dog of Season Three, with obsessive concern from people who watch *Shtisel* as Malka watched her soap, as if the characters were real people not careful literary constructions.

If we're not told some detail about these fictitious characters it's because we don't need to know. If we were told it might introduce an

8 The 'kosher' mistranslated "haimisch,", i.e., home, neighbourhood, for a more efficient, local mail service. Kosher could refer to the licked adhesive.

extraneous tangent. Breast cancer? How would the implications of a vulnerable or poisoned nursing fit the metaphoric construction? The death itself — not the how or why — is the only detail we were intended to consider. Omitting the irrelevant may be why this season omits any sign of Shulem's reconciliation with Akiva or with Nuchemafter the close of II,12.

Left unexplained, Libbi's death a few months after she bore Dvoralleh embodies the mortal risk Ruchami is taking to serve her husband's purity. Indeed all the characters make their decisions, whether moral or mundane, in the shadow of a death that can strike anyone, any time, with neither sense nor justice. Hence the three unexplained deaths. Explaining them might make death seem logical.

Why is the episode titled "White"? It's not the white flag of surrender that Shulem picked up only to reject in Episode One. Perhaps it refers to the absolutism of people who see the world in terms of black and white, disdainful of the intervening moral shades of grey. If the Haredi anti-film extremists are a comic example, the potentially suicidal Ruchami may prove a tragic one.

Episode 6: *Cestrum Nocturnum*

From the previous episode's high drama the mood here shifts into a lyrical take on the male suppression of women. The eponymous night-blooming jasmine is an emblem of a hidden beauty and power. Only at night does it emit its beautiful aroma, a mix of "honey and winter." As Racheli tells Akiva,"The nights I'm not here there's no-one to smell it. It's not fair there's no one to smell it." She is enigmatic about why she would be away: "It happens."

In context, that latent beauty may emblematize woman, suppressed by the authority of their men and thus a wasted potential. In their separate stories Akiva, Shulem and Zvi Arye are forced to confront their need for the women whose lives they suppress.

Zvi Arye is the comic form of male power. First, he's offended that wife Tovi — without his awareness and permission —took driving lessons, got a license, then further circumvented his will to buy a car. "Women don't drive," he insists, "It's not right." He's even unaware that its color, green, is his favourite.

Zvi Aye then ludicrously counsels friend Zilberstein, whose wife is tired of her dishwashing job and wants to go to an orthodox women's college to become a lawyer. Even though she's the breadwinner, Zvi Arye insists, Zilberstein must assert his God-given authority: "'And he shall rule over you,' you see?" "If you ask me," he pontificates, "you're the man. You have to rule. No two kings can wear a crown." Lying, Zvi Arye claims that when he refused to let Tovi get a driving license "She went to bed happy to know her man is in charge." This transparent swagger recalls Shulem's posture in the Eclipse episode (I,7).

At home, hearing Tovi bought a car, Zvi Arye tries to assert his authority: "I don't want to say anything you'll regret." That, of course, precludes the possibility that he might be the one with regret. Before he can say anything she nails him. She enumerates her daily three hours on the bus and her onerous responsibilities at home and at work: "The day you become the breadwinner, then you'll decide where the money goes. It's me now and I need the car." Zvi Arye has only one response: He yells at daughter Chaya to leave the room. Now Zvi Arye's withdrawal from a singing career (II,11), to Tovi's disappointment, proves all the sadder. His suppression by Shulem the more tragic.

To save face, Zvi Arye announces "I decided to let you keep the car" — but only if she parks it outside their neighbourhood so nobody knows it's theirs. "This is important to me. I'm the man in the house." He needs his false appearance of power all the more because he's so dependent upon her. In their drive he's impressed by the power windows but troubled by the 22 preprogrammed radio stations. Too much danger from the outside world. After hiding behind his hat in their neighbourhood, he relishes the ride. It makes him feel like a king.

As Tovi drives him to the Kollel the next morning he falls asleep in the back seat. Chattering on with a friend about a photocopy issue at work — "high tech" — she forgets he's there and leaves him locked in for the day. At home, when he recovers from dehydration and Zilberstein visits, Tovi plays along with her husband's pretence to carless authority. She even denies her license: "What my husband says is sacred." She also plays along with Zilberstein's denial that his wife is taking courses. The women may be asserting their will but they remain restricted. As we've seen, the locks hold, even if only psychologically.

<p style="text-align:center">***</p>

Shulem too preaches what he doesn't practice when he counsels Akiva to deepen his relationship with his formal wife Racheli. In what may be the first time we see Shulem make food for anyone, he prepares a slice of garlic toast for Akiva. There's more nutrition in his advice: "When the train pulls into the station you forget everything and jump on. Linger too long and you could lose everything." When he wants to say "The world won't wait for us," he instead reveals his latest wound: "Nechama isn't waiting for us."

Shulem was taken aback when Nuchem and Nechama asked him to officiate at their wedding. "She taught me how to live, how to really live," avows Nuchem. In a comic version of his authority Shulem insists that in his kitchen Nechama can have a cup of coffee or a glass of tea but not a cup of tea. He's immediately deflated. When he hears their news he drops the glass, then wrestles Nechama for the broom to clean up the mess. Nuchem defends the lovers' rush: "Life is short, weren't you told?…Even shorter than it really is." To that the unexplained deaths of Libbi, her mother and Sucher implicitly attest.

So when Shulem feels a pain in his heart he rushes for a cardiologist. His problem may be that garlic toast, compounded by his rage at the health services man who can't get an appointment for two

weeks — March 25.[9] Shulem is only mollified when the man's superior comes on. To her promise to respond Shulem snaps: "You'll get back to me like my dead wife will get back to me" — clearly forgetting that she has. At this the woman starts to cry. This Mrs Hemdat responds to Shulem's apology with her own. Since her husband died a month ago her normal life and work are a burden. Shulem makes an uncharacteristically open apology: "I'm a widow myself and an orphan.... May you know no more sorrow."

As it happens, Mrs Hemdat finds him an appointment for that afternoon, where he's diagnosed with angina pectoris. That is only a possible precursor to a heart attack. Doctor Neuman prescribes catheterization, some medicine, that Shulem stop smoking (a practice betrayed by his beard) and to get a girlfriend. That would make the patient a new man too. Loneliness is the main cause of heart attacks. Shulem is bemused to learn the doctor has "a boyfriend, which is just as good." Shulem on his balcony phones the health agency in vain hope of finding Mrs Hemdat.

<p style="text-align:center">***</p>

Akiva's challenge is to negotiate his commitment to his two wives, the dead Libbi and the living Racheli. He is at first wary of Racheli's exuberance when she invites him to a trip to Russia: "We barely know each other." He relents only after she assures him that Libbi is as present in St Petersburg as in Jerusalem. He is further tested by her cancellation of the trip and her revealing that she has for years suffered from manic depression.

Akiva shows his powerful gentleness when — over the phone — he calms the crying Dvoraleh by reciting the *Shema* and singing her a prayer. To Racheli's mental disorder he responds with an affectionate

[9] As it happens, on that date in 2021 Netflix started to run Season Three. Like so much else in *Shtisel*, that may be coincidence, human agency, destiny ... or divine programming?

smile: "You shouldn't be [ashamed]. I'm so glad you told me…. You don't know me if you think I'd give a hoot."

But then he lapses. He withdraws, then retreats to the window to look out on the emblematic jasmine. Returning to Racheli, he asks for her Libbi portrait. She has to remind him of their one-for-one agreement. To Shulem he only admits Racheli "is not simple." Out of her "strange kind of stubbornness" she wouldn't give him the painting.

He's slightly more open with his friends at the restaurant, who downplay the seriousness of mental disorders, having been diagnosed with enough themselves. Especially Farshluffen, who admits both to his own several mental disorders and his confidence they are all invented.

Akiva has been ignoring Racheli's phone calls all day. He assures Dvoraleh that they will "celebrate your birthday alone with Mommy…. Mommy is always with us." At the end of the day — when the flowering jasmine is about to spring to glory — he comes to the melancholy Racheli to explain his detachment. When she meets him at the door she hands him the two Libbi paintings: "I don't need them anymore." She closes the door on him and returns to her depression. The camera pulls away through her window onto the *Cestrum Nocturnum* outside, a beauty that has to be accepted on its own terms, on its own schedule. Some men are not ready for that.

Episode 7: A Long Path that Seems Short

There are many reasons why withholding key information may be an effective narrative strategy. Indeed a key element in the story-teller's art is the distinction between the plot and the narrative. The plot chronologically tells what happened. The narrative is how those details are arranged for maximal meaning and effect.

Shuffling the timeline in story-telling may increase suspense and audience engagement. It can add dramatic irony as the new info casts new light on what has passed. More generally, it can encourage a liberality of judgment. It reminds us that we don't always know

everything feeding into a character's — or even a person's — experiences when we judge them. Remember how our view of Lippe changes in II,5, when we learn Giti's response to Lippe's generosity.

So far, the flashbacks in *Shtisel* have served an additional function. Like the very prominent dreams, they have reaffirmed the assumption that we have an existence beyond the material. The Haredi observe this with their mezuzah-kissing and perpetual blessings.

Here the past lives on. It can be remembered as if re-experienced. Hence Akiva's recollection of Libbi's first kiss, in childhood, and his later memory of their wedding night, when he paused her disrobing to sketch her. Conversely, Shulem's flashbacks relive his denials of Dvora's desires, from blocking Akiva's phone calls to failing on her deathbed chocolate request.

So, too, dead characters are here available for conversation. Hence Elisheva and her two husbands, who assure there is room for a third. Dvora remembers Shulem's refusal to replace the kitchen chairs — but she can't get up to answer the phone. And Libbi poses for Akiva and urges him to sell his art. As flashbacks replay the past dead characters return.

In *Shtisel* all these levels of reality/fiction are accorded equal heft. In the climactic conclusion to Season One, remember, Malka and her dead husband are watching her "life" scene in the hospital ward — on television! The medium forbidden on earth is approved in the heavens. The characters are living in a fiction. As indeed we are, living out our own insubstantial lives — for the moment. Our spiritual existence is the long path, the material one short.

Two flashbacks govern the episode that launches the last third of this season. Occurring here packs a whallop their earlier appearance might have lacked because they may be imminently repeated. Four years ago Ruchami's life was threatened by her pregnancy because she had a pulmonary arterial hypertension. She now resumes that risk.

The first flashback replays the diagnosis, consultations, the characters' conflicted emotions. This re-living — playing the past in the present tense — recaptures the urgency in the mortal dilemma Ruchami and Hanina now face anew. Back then Ruchami refuses to risk a stillbirth to save herself,. But the rabbi cites the Talmud's insistence that "the mother cannot be at risk."

In the second flashback Hanina watches Ruchami's screaming delivery — of the stillborn baby boy. At the burial another young couple suffers the same grief, over twins. When Hanina moves toward Ruchami — "Let me be with you" — she moves stolidly toward the small coffin: "I'm there. In that box." This is Ruchami's Death-in-Life. Her present resolve for pregnancy is her attempt to redo that incident. As, in a minor-key parallel, the *bashert* Shira told Yosa'le she wishes she could repeat and redo their first meeting.

Back in the present, Hanina's joy at the beauty of his wife's supposedly pretend pregnancy turns into horror when he realizes the pregnancy — and danger — are real. "How could you not tell me this?" "You wouldn't agree." Hanina says he would not have a life without her. In contrast to their last bedroom scene, when her generous deception worked, now Hanina turns his back on her. He says she's been turning her back on him for months — to hide her condition. She is risking her life to give him a child while honouring his religious qualms against surrogacy. With this generosity she herself disobeys the Torah privileging the threatened mother over the child.

Five months pregnant, Ruchami remembers "there's a chance it will be fine." But as Hanina seeks help, their doctor insists Ruchami must again terminate her pregnancy. He sees only one chance in a thousand she would survive. For religious advice, Hanina returns to the yeshiva head who had approved the surrogacy. The rabbi insists he seek instruction in the Talmud. Against Hanina's urgency the rabbi advises taking an hour or two to immerse himself in the Torah, as in a *mikvah* (the ritual bath). He provides the episode's title: "There is a short path that is long, and a long path that is short."

As Hanina reads he sticks on one particular statement, from *Job*: A man is considered righteous if he has one defender against 999 accusers. The Torah has produced the same odds as the doctor did. At a thousand to one, the odds are long. But these rhyming odds may be misleading. Would one accord the same weight of a single voice against 999 to declare guilt? And in a literally life-threatening situation?

Hanina does not fully grasp the lesson here until he spots an old Jew eating alone at Giti's restaurant. As Lippe confirms, Rabbi Zimmerman was incapacitated by an accident. "I also heard he's better. The prayers helped," says Hanina. No, says Lippe, "He's with us, but not quite." Unable to study anymore "his life has been taken away." Perhaps Hanina finds Zimmerman's still being alive sufficient proof of the power of prayer. Or that dead existence recalls Ruchami's quote him (episode five): "Without something worth devoting your soul to, what's the point in living?"

Instead of marshalling her parents' support Hanina throws his lot in with Ruchami: "We'll be afraid and pray and keep being afraid. Then with God's help we will have a boy." He catches himself: "Or a girl. And you will be well, Ruchami." They will continue in fear, prayer and love because "That's how it is. When you have something precious you're afraid of losing it." Man lives the short path, his soul the long.

In his own, minor key, Shulem also has a crisis of health and faith. Scheduled for his catheterization, he is advised it's a "must must" to have someone accompany him. Ruchami can't because she's going home early, visibly exhausted. He hesitates to pull Zvi Arye away from his religious study, especially after Zvi Arye suggests Shulem come study with him. Akiva is caught up in his own challenge. Welfare is coming to investigate Dvoraleh's new home, which has not yet been set up, and Racheli isn't answering his calls. Under the pretence of not wanting to worry his children, Shulem asks Nechama, who's happy to oblige.

Shulem corrects the doctor's assumption he has found a prescribed girlfriend. Instead he adopts Nechama's "acquaintance," again denying her engagement to his brother. But her presence proves effective. As he enters his ECG she assures him: "I have a good feeling.... The main thing is not to worry." Then, "The body is its best doctor." She joins his *Song of Ascents*, his personal prayer of choice.

It works. The doctor runs a second ECG because the first had a problem: there was no problem. Shulem's heart is fine. He needs no treatment. "The heart is its best doctor," Shulem misquotes Nechama.

Nechama rejects his offer of a taxi ride home, despite his line: "What's a small detour compared to a bypass surgery?" That is a secular parody of the conundrum of the short and long paths. So, too, the cabbie: "The meter is running. You can drive with me forever."

In the exchange of affectionate close-ups — the street between them — Shulem and Nechama acknowledge the relationship that might have been. Then the bus — like Nuchem —whisks her off. Relieved, Shulem resumes his forbidden habit of smoking. He bums a cigarette off strangers at his bus stop — then wishes them good health. Except for his damage to himself and his family, Shulem is a comic figure.

<center>***</center>

In light of Ruchami's imperilled condition, Shulem's glib wish for her early maternity leave (III,1) now seems insensitive (*i.e.*, true to character). He rises to the occasion when he rouses Akiva from his 1 p.m. boozy nap with an exhortation: "You must save Dvoraleh instead of yourself." Fathers don't merit the primacy the Torah accords the mother. "You can't play around with the Zionists" *(i.e.,* Welfare Department, the secular governors).

Shulem mobilizes to help Akiva move his and the baby's things into Racheli's flat. He pauses to buy her a potted flower: "There's no argument in the world a plant can't solve. Twenty shekels." (He expects reimbursement?) Like his earlier claim for garlic, Shulem's faith in the plant is a parody of the rabbi's faith in the Torah. In the event, Akiva

proves too honest to take credit for the gesture, telling Racheli the plant was Shulem's idea.

Racheli and Akiva prepare for Orly's official interview. For Racheli, "We'll put on our act for Dvoraleh then go our separate ways." A closeup on the metal crib bits suggests Akiva is trying to rebuild the relationship from the breakage by his withdrawal from Racheli's mental condition. He will deploy all he can, like using a knife to turn a screw. After they silently chop food Akiva makes her dinner. When Orly arrives on time, Akiva's optimism trumps Racheli's negative expectation. Orly does not kiss the entrance *mezuzah* — Shulem's dread Zionist!

The formally newlyweds then perform a domestic role-playing that is truer to their emotions than either would admit. Or even realize. That is, the stories they tell the social worker are what she wants to hear, what they need her to believe, what they are offering each other as "stories." In fact they reveal the emotional truths they are not yet ready to express — or believe — themselves.

Akiva admits the intensity of Libbi's loss: "I died with her." The difference in his life since he met Racheli is "like night and day." "When I thought my heart would never feel again it happened. I met Racheli. I cared for her. I missed her.... I love her. I want to build a home with her." As Akiva could not lie about the flower pot these admissions ring true.

Racheli also speaks with emotional credibility. She was wary about any relationship with him. Not only was he a widower with a baby, she had often sworn never to marry an artist. She knows he *has* and *loves* a dead wife, dead but present and perfect. "And yet he loves me too....People are complex. I know that." "I feel I have this pact, this shared fate with Libbi." They share her daughter and her love of Akiva. "Dvoraleh is my child. That's how I feel."

Both radiate as they speak with intense emotion. But after Orly has left, satisfied, Akiva prepares to take Dvoraleh back to Shulem's.

The married but still only potential lovers retreat from connection. "You're a pretty good actor," Ruchami says, "I believed you."

Now Akiva might have said "I meant it." He doesn't. Instead: "I believed you too." He retreats to "I'm forever indebted to you" — and he'll collect the furniture tomorrow.

We believe both of them. They're afraid to. They are not yet open to Hanina's and Ruchami's resolve. As Akiva walks away in the night Racheli watches him beyond the dark flowering jasmine. Like Shulem and unlike Ruchami and Hanina, Akiva fails to make the commitment he feels and needs.

Episode 8: Mamme, Mamme

"I think we made a mistake, Nechama," Shulem says when he appears in her doorway at 10 p.m. "We gave up too soon." As he bears the Brizel cheesecake, he's trying to redo — and correct —the coffee date that he slept through, when he lost Nechama to Nuchem. Knowing when to stop, giving up too soon, going on too late — that's the theme of the three stories here.

Nechama hasn't yet cashed her 3,000,000 shekel[10] lottery cheque. Fearing the money might ruin her life she prefers to ignore it. Her decision to donate it all to Shulem's school unleashes Nachum's larcenous nature. He tries to force Shulem into giving him half: "Half to God and half to you" — with Nuchem as God. Nechama "doesn't have to know."

With this reflex avarice Nuchem ruins his idyllic romance. As he makes Shtisel an omelette he admires the cultured Nechama, who reigns in the radio studio "like a high priestess in the Temple." Serving his priestess, Nuchem brags about having silenced the producer. Echoing

[10] US$910,000.

Akiva, "I was in hell and she pulled me out like an angel. Now I'm in heaven."

Learning of the lottery win redefines Shulem's "woman of substance." Now "substance" means money not character. Though he cooks Nechama a fine dinner — steak *and* tuna — Nuchem's restored energy turns negative. He defines a *maven* (authority) as "a person who makes up things he knows about." Both brothers qualify. Here Nuchem falsely claims to have known about the lottery win. Later Shulem will bluff that Akiva told him about Racheli's mental issues. Equally suspect is the adage Nuchem attributes to his mother: "Take while giving; run while beating." Dvora was never that aggressive or self-serving.

Hoping to resume his courtship Shulem informs Nechama of Nuchem's attempt to get half her donation. That only angers her: "I'll try to forget this ever happened." She even rejects his cheesecake. In the episode's last shot Shulem sits alone at his kitchen table eating his Brizel.

As his other relationships depended on women feeding Shulem, his solitude often has him eating by himself. We recall how he defined his marriage to Dvora, never having said he loved her. She warmed his morning butter. Failing with Nechama leaves him alone, indulging himself. A black right side frame boxes him in.

Shulem is more effective in persuading Akiva to deepen his relationship with Racheli. "God sent you a fine woman who wants to help you... You must say goodbye to Libbi." In Racheli, Shulem avows, "You won the lottery!" The allusion parallels Racheli with Nechama.

Before that, the married "couple" perform their act one last time for the Welfare Committee, earning the closing of their "case" and Akiva resuming Dvoraleh's full custody. As Shulem gloats, they saved Dvoraleh from the Zionists and from *Mizraim* (Egyptian bondage). For Nuchem, cashing in the lottery kept the money from the Zionists too.

To Akiva's fulsome gratitude Racheli is modest: "I could do nothing else." However, neither will express to each other the love they

revealed to Orly. They can't step into the truth of their "story." So Racheli suggests they set a date to apply to the Rabbinate for a divorce. "If that's what you want," Akiva replies, still passive.

But first he wants to paint her. This is an audition of the painter not the subject. Akiva keeps seeing Libbi, first behind Racheli, then replacing her. Sensing this, Racheli rises, goes to open the door, then nods for Libbi to leave: "Please." Reluctantly Libbi does. Here Racheli respects Akiva's vision, playing a fantasy she doesn't see as real. Racheli respects Akiva's predicament: "You can't force yourself... It really doesn't matter, does it?... You can stay or leave. It's up to you, Akiva." Libbi has the last word: "Let's go home, okay?"

This play between the image and the real woman continues. Dvoraleh calls the Libbi in the gallery paintings Mamme, with Akiva's encouragement: "Mamma is always with us." "Enjoy your family reunion," Kaufman says, off to a date, leaving Akiva to lock the gallery after visiting with the Libbis on the wall. When Akiva runs urgently — to find the gallery robbed — it's a dream. Shulem is burning all the Libbi paintings in the alley. Finally Akiva apprehends Shulem's urge to change wife and muse.

Again Akiva acts emotionally through his art. First he visits Libbi's grave, where he says goodbye, asks forgiveness and for a suspension of her visits. "I know you'll understand." Then he rouses Racheli to paint her. Akiva's urgency here recalls his need to paint Libbi on their wedding night.

This time he manages to paint Racheli, sans Libbi. His Racheli has more intensity and colour than his Libbi. Instead of her grays and blues, he surrounds Racheli with flames, drawn from his dream of Shulem burning the Libbis.

The image is profound. In the wider community Racheli could be read as the phoenix rising out of Libbi's ashes. That is, the passion for a beloved, the women's pact, renewing itself. Or Racheli and Akiva, taken together, suggest that hermaphroditic bird eternally renewing itself. This image of vitality and purification also proves Akiva's

resurrection. Especially as Racheli urged him to rise to the challenge of the true artist, to be the bird not the impersonator (III,2).

Further, in this intense drama Akiva apprehends his new beloved in her totality. The strength and dignity in her bearing stand against the infernal pressures that envelop her. In the painting Akiva embraces the complex woman, in all her ambivalence.

Finally, from his Judaism comes the association of fire with the presence of God, from Moses's burning bush to the burning punishments of the errant and the blessings in ritual. This work is the culmination of Akiva's exercise of religious spirituality in art. Unlike Shulem's rejection of Racheli for being imperfect, Akiva's painting devotes compassion and love to the human. The painting is the Art version of their marriage, their true marriage. so much more profound and meaningful than their merely formal religious ceremony.

Clearly Racheli is gripped by Akiva's articulation of her. She knows he has submitted himself to, tried to understand, and embraced her in all her ambivalence. He has finally seen and painted her, not Libbi. She says nothing.

<p style="text-align:center">***</p>

With uncommon directness Yosa'le tries to leave his engagement in favour of Shira Levy. Shira Levinson begins their date with a joke about her family's excessive provision of wedding lanterns. But from the illumination she draws out of him — "I'm thinking about [Shira Levi] ... every day. Every hour....I can't hide it from you anymore." — she walks home desolate

In the face of his parents' pressure Yosa'le again shows his strength of character. He confronts Lippe with lying: "You said you didn't find her." Of the woman she has never met, Giti vows "I will not let her ruin your life." As with Ruchami, Giti is enraged that her son presumes to pick his own mate. "He'll marry her over my dead body!" She won't attend the wedding or visit their home.

Persistent, Yosa'le has Lippe arrange another date with the desired Shira. He wants to have the same hotel lobby table: "The first

meeting was from heaven and it was so good. Yet I let the world confuse me and distort it." Shira buys the drinks, because she can afford to, and even suffers a beer for him.

Though they clearly love each other they can't break their cultural fetters. When Yosa'le admits his mother's opposition to their match Shira visibly retreats. Her family cancel the match. Yosa'le's last hope is that Lippe can convince Giti about what she may not know: "true, unconditional love."

<p style="text-align:center">***</p>

If the other relationships are struggles over whether or how to resume, Ruchami's approach to her life-threatening motherhood is a salutary alternative. Preparing for the best — to have a daughter — and the worst — dying in childbirth — she tapes a series of messages on cassettes to be played for her. This is a salutary alternative to the videotapes Aronofsky made of the elderly, for exploitative sale (II,8).

For her daughter's fifth birthday, Ruchami shares a memory of a school embarrassment. One for her eighth birthday recommends training on a musical instrument. Her twelfth will find her "a young woman, whose every deed matters." In those trying days "remember that your mom is always with you." Her tapes promise the maternal presence Akiva promises Dvoraleh.

Episode 9: Where does everyone suddenly go?

This nine-episode drama aptly ends on a celebration of story — and a test of the viewer's faith. Three forms of story-telling provoke different responses that measure out our own spectrum of existence. In his last appearance Shulem enters a life of solitude, but to brace himself he cites a writer to re-affirm his family's eternal presence. Shulem saves himself with a story. The last scene leaves us uncertain which "reality" obtains. Our initial reflex tells us one thing; the context, quite another.

<p style="text-align:center">***</p>

Sensing Shulem's concern about her mental disorder, Racheli leaves with a discreet: "I sometimes forget that not every story is for everyone." She told Shulem that she first met Akiva when she passed the gallery and was struck by his portrait. "Libbi was looking at me from a painting as if she were waiting for me." The artist had painted his dead wife but "I had never seen more life in a person." This experience snapped her out of her deep depression, restoring her will to live. Shulem seems accepting — "Well, we all have our problems." — but he gives her the bum's rush. He's disturbed by her "nice story."

Now Shulem insists Akiva drop "this woman whose mind isn't right." He dismisses Racheli as blindly as he dismissed Akiva's painting of idealized motherhood (II,12)— without seeing it: "I don't want to know her." This after arguing that Akiva should forget Libbi and marry the wonderful woman who helped him recover Dvoraleh. Akiva accuses Shulem of undermining all his romances — as if to keep him at home: "If you could, you'd take me to your grave."

When Akiva next knocks on Racheli's door she has been studying his infernal portrait of her. Having sensed Shulem's antagonism she expects the worst: "You changed your mind. You're going to stay. At home. With Shulem." To her relief Akiva stands solid: "This is my home, with you and Dvoraleh. This is my only home."

Shulem pretends shock and disappointment when the broken Nuchem reports Nechama has cancelled the wedding. "Did she say why?" "She muttered something about trust, shmust." "It pains me to hear this," says Shulem: "Women. Go figure." In his feigned innocence Shulem is living a lie.

Though Nuchem doesn't know of Shulem's visit to Nechama, he senses his jealousy: "You piece of *dreck*!… It hurt you to see me happy." The brothers wrestle in anger. "Don't make me hit you back," Shulem vaunts, provoking Nuchem's "You're all talk!" When Nuchem charges him with *chutzpah* Shulem slaps his face. "You might be my older brother," Nuchem says, "but you are a small man." He holds his

fingers inches apart: "A very small man." Lying on the floor, Nuchem cries helplessly.

To make amends, Shulem secretly phones Nechama at work. He asks her to take back Nuchem, that "very dear man who loves you." As for the money story, "I didn't mean it. I was jealous of him." But the damage is done.

<p style="text-align:center">***</p>

When Hanina finds Ruchami's cassette collection he plays her greeting for their daughter Hanneleh's 14h birthday: "Nothing makes me happier than knowing you're alive in the world.... Whenever you feel that you need a mother's embrace, close your eyes and know i am hugging you very tight. Mom is always with you. Mom hasn't gone anywhere. I just moved to another room." This assumption of the eternal mother parallels the continuing presence of Libbi and the mother Ruchami would like to become.

Ruchami's "Hanneleh" evokes her Hannah Karenina, her secular heroine in her precocious reading career whom she sanitized to fit her own culture (I,6). She wouldn't name her after Hanina because Jews don't name their children after the living. In that choice of name Ruchami addresses her daughter as an extension of her own character.

Hanina listens to the tape on his earphone while Ruchami sleeps in front of him. It's as if she were already speaking from the dead. This so moves him that he rushes out to buy their own home, in which to raise their children: "Soon we'll be a real family."

Of course, Hanina runs into the old joke Lippe heard in the restaurant: "If you want to make God laugh tell Him your plans" (cp I, 4). In Lippe's version, "Tell God your plans and He'll cry with you." In the excitement, Ruchami collapses and is rushed to the hospital.

<p style="text-align:center">***</p>

Giti awakens from the opening scene earthquake terrified: "I have a bad feeling... Maybe God is trying to tell us something.... to repent and mend our ways." Lippe assumes she assigns him the repentance. Having felt Malki's animosity, Lippe is relieved when she

quits the job to give her family a fresh start in Ramat Gan. Lippe still can't open Giti: "Her story is her story. We all have our own story."

Giti still rejects Yosa'le's marriage choice. His parents lied to protect him. Lippe says she's unfair to deny him the woman he wants and loves. He futilely tries to assure Yosa'le: "It will be fine…. One day all will be well."

In a last desperate attempt, Lippe turns Giti's dread constructive: "If someone needs to repent it's you. I won't let you ruin Yosa'le's life. I love you so much. But I can't live like this. Conditionally." That word he picked up from Yosa'le, but it covers the years his marriage has been shadowed by his Argentine truancy (I,1).

This personal affirmation works. We infer her change of mind when we see Lippe and Giti in a living room chat with the Levis, while Shira and Yosa'le joke on the balcony. The couple are naturally at ease; their parents, strained but trying. From their flat, furnishing, dress, manners, the Levis seem socially and economically above the Weisses class. But Giti's prejudice persists. The family meeting is interrupted when Hanina calls, summoning them to the hospital where Ruchami has been rushed into surgery to deliver the baby.

Lippe drops Giti off and then circles in futile search for a parking space. Another short path turns long. Picking up Giti's religious fear, he leave his car in the street, runs, falls, and panicked starts to pray: "Please don't touch her. Take me!… I'll mend my ways." Then a miracle appears to happen. A blinding celestial light envelops Lippe. The miracle has happened. God has taken him to leave us Ruchami. The lengthened short path turned into the long. But no. It's the headlights from the obstructed truck. So much for miracles.

Shulem finds himself isolated when his son and his brother turn upon him for his interference and selfishness. "You can't just get up and leave," he tells Akiva. "I can and I have to." Nuchem leaves "to work out some issues with my bride." Shulem grasps for a last brief unity: "Not this way. Don't leave yet, please. One glass of soda. I beg of you."

Over that glass Shulem tries to salvage his squandered authority. Reverting to his posture as sage, he cites Isaac Bashevis Singer. The famous yiddish writer may have been the rascal (*shaygetz,* a.k.a gentile lad) that Nuchem appreciates but he had this one brilliant insight: "The dead don't go anywhere. They're all here. Every man is a cemetery. An actual cemetery, in whom lie all our grandmothers and grandfathers. The father and mother, the wife, the child. Everyone is there all the time." Singer's proposition curiously echoes the subject of Shira Levi's science research: the genetic change passed on from one generation to the next. As in the genes, people's behaviour can bear the consequences of their ancestors' experience. This argues for institutions to allow the flex that new generations may require, a frequent theme here.

Suddenly Shulem's empty kitchen teems with his family, the living and the dead, including Malka, Dvora, Libbi, and some children.

Had this climactic shot ended the season— with the Singer quotation actualized — it would have completed the entire drama's experimental treatment of various levels of experience as equally real. As the season opened on the individual Akiva's visit with his dead Libbi, it would complete the arc with the visit with the family dead.

But the writers added a scene. In tone it seems an epilogue, slightly outside the narrative. They went beyond the solitary Shulem with his resurrected family. Similarly, at the end of Season Two they left Shulem's climactic madness to close on the union of Libbi and Akiva. Now the drama concludes on Shulem's granddaughter's baby, the extension of the Shtisels/Weisses/Toniks. They close not on the echoing past but on the ever-promising future.

The writers give us the happy ending we crave. Against 1,000 to one odds, Ruchaml apparently has her baby daughter and both survive.

Okay, you can stop here. Or — I propose an alternative conclusion for your consideration. I suggest the ending is rather more complex, ambiguous, indeed another moment where the dramatic text reads us as we are reading its characters.

First, some elements of that last scene are unsettling. The abrupt brightness and Ruchami's sudden heartiness suggest a possible dream. This is confirmed when Ruchami looks up and smiles ... at us! Thus breaking the Fourth Wall —when the character addresses the audience's reality instead of just the stage one — breaks the scene's realism.

The scene's falseness is confirmed when the music from the previous dinner with the dead plays over Ruchami. It wasn't heard over the three men's chat. It starts when the dead arrive and continues over the scene of Racheli and her baby. The music places both scenes on the same level of reality, i.e., visits from the dead.

Though a character's death usually connotes a bleak finality, not here. The drama has continually depicted the presence of the dead, their continuing support and engagement. The Singer quotation only verbalizes that theme that ran throughout the drama. Yet many viewers, moved by the Singer quote, seem to have forgotten it by the next scene.

My online suggestion that evidence points to Ruchami dying incurred general indignation and denial. Indeed the director of the Shtisel Official Facebook website refused to run my argument and claimed she had it from the writers that Ruchami is still alive. An odd claim for any fictional character.[11]

Some correspondents declared themselves in "the camp of life." Now, in arguing Ruchami's death I am not in the "camp of death." In the cosmos of this narrative I am rather in "the camp of afterlife." Because that faith is the most distinguishing element of the entire drama. It began (I,1) with Akiva's dead mother, in a dream, complaining about her deep freeze in death as in life. The first season ended on another mother watching her life on TV, with her dead husband, from heaven. The second season began with a comatose mother's advice to her son in a dream. Apart from the romantic epilogue, it ended on Shulem having lost his connection to reality. The third season began

[11] When I questioned her claim about the writers and advanced my ambiguous ending I was expelled from the website.

with another visitor from the dead, Libbi. That is, the entire structure supports the reading that the last shot is a beneficent visit from a dead Ruchami. A simply realistic end would jar against the drama's structure.

Nor need that ending be sad. Ruchami only grows in this interpretation. She doesn't bet against the odds but accepts them. In a dramatic assertion of independence she willingly sacrifices her life to have a child. In both her pregnancies Ruchami rejected the Torah's valuing the mother's life over the newborn's. She refused to sacrifice her baby to save herself. Denied her choice on the first one, now she takes it. Her radiant satisfaction may derive from having finally been allowed her will against the religious, medical and family prohibitions imposed on her.

When Ruchami wrote her "letters to my beloved little girl I will never give birth to" (III,2) she described the piercing black hole she felt inside: "This hole inside me is shaped like you." The absent daughter was already a presence. Now the image of the presence may connote that absence from the material world. For her family now Ruchami might be, as she promised her daughter in that letter, just watching, caring, from "another room."

Central to Ruchami's characterization is the absence/presence paradox. In I,1, seeing off Lippe, she says "I miss you already." He's still present but she already senses his absence. In substituting for her parents — "nursing" for Giti, writing for Lippe —she was a present response to their absence.

Compared to this generous, assertive, fulfilled Ruchami the cliche happy ending shrinks. It rests on her character not on a miracle. This ending assumes we believe in the characters' (and our) spiritual life beyond our mundane. The entire drama has espoused this spiritual layering of existences — dreams, visions, memories, visits from the dead — why now reduce life to the material world?

One final consideration. Call this my *Lekoved* Covid Clause. The ambiguous ending evades a thorny issue that is especially pertinent in the Covid-19 climate in which the season was produced and released.

Would the writers advocate sole reliance upon faith in the face of enormous medical evidence? Should we?

In our pandemic days there is no shortage of confrontation between the secular and religious authorities. On one side, the social order demands safety compliance and some religious restraints to curtail the virus. These some religious figures reject in the name of religion and freedom — to their own, to their congregants' and to their communities' peril. Does one miraculous "happy ending" justify the affliction and death of many others? Of any others? Is this a time to promote prayer over medical responsibility?

Perhaps the Talmud has our answer again. The short path could be the challenges and rewards of our brief material existence on earth. On this level, "mother and daughter doing well" is the happy ending — however here implausible. The long is our soul's life, for which liberation we wait and strive. In this context Ruchami's happiest ending honours the integrity of her choice and gives her a daughter for eternity. Hence the episode's title: Where does everyone suddenly go? Back to where they belong. Their source.

I suggest the writers left us with alternative happy endings. If we so believe in the power of prayer we may feel reaffirmed by Ruchami's "successful" delivery. But if our faith extends beyond the rewards of life on earth, we may find that the purity of her will has won her a superior grace. As the last dinner scene reminds us, motherhood doesn't end at death. We see Dvora handing Akiva some *challah*. All have escaped the freeze that launched the drama.

Is Ruchami dead or alive? She's a literary figure, so why does it matter? The story ends there. Whether in heaven or on earth Ruchami is happy. If we believe the spirituality we espouse would we really prefer an earthly satisfaction over the eternal? Her survival might have been a happy ending on the short road, on earth. Sacrificing to bear a daughter to support from heaven might well be considered the happier ending. And — especially for our time — the healthier.

Part Two

Autonomies

After their brilliant collaboration on *Shtisel*, writer Ori Elon and writer/director Yehonatan Indursky developed another family drama with a more explicit political dimension. The six-episode TV series *Autonomies* was later reset into five for a 3 1/2-hour feature film release in 2018. That's the version I discuss here. A popular presentation at Jewish Film Festivals, it certainly warrants distribution on DVD or a streaming service.

In *Autonomies* the authors posit a near-future Israel in the aftermath of a civil war. That began with an orthodox demonstration in which 13 yeshiva students were killed. Thirty years later, the ultra-orthodox have established the Haredi state Autonomy, centered in Jerusalem. The secular State of Israel has its capital in Tel Aviv. As in *Shtisel*, the writers have stepped away from the more common conflict between Israel and the Palestinians, to focus on tensions within the Israeli Jewish community.

Their respective cultures are instantly identifiable. Two girls with bare and tattooed legs connote Tel Aviv. At the Autonomy's border entry point Haredim solicit donations. Clearly the modern thrives more than the old. Indeed the Autonomy hospitals are unfunded, with decaying equipment and salaries suspended for two years -- resulting in a campaign to rejoin Israel.

In the title graphics a diminutive orthodox Jew is dwarfed by a landscape of columns and a gigantic book that threatens (like a leviathan) to swallow him up in its pages. The figure points ahead to the drama's hero, Yoni Broide, a virtuous but weak orthodox Jew who is an "orthodox undertaker." His name evokes the Biblical Jonah (whose story he retells in Episode 4), that crucial story in the celebration of

Yom Kippur, the Day of Atonement. Like Jonah, Yoni will try -- futilely — to escape his commitments, both to family and to God. He will sink into adultery and kidnapping before he achieves the purity for his ultimate sacrifice.

For Yoni and the other central characters, there is a constant struggle between their personal will and their responsibilities. That is, personal autonomy is as much at issue here as that of the orthodox state.

Now the two Jewish states are considering reunification. Many in the modern State oppose renewing their excessive support of the orthodox "parasites," who refuse to join the Israeli army, detach themselves from the social mainstream and promote a narrow, antiquated school curriculum. The orthodox refuse to surrender any of their authority. They consider those modern Jews to be apostates. According to the Autonomy's leader, the Rebbe from Kreinitz, reuniting with the Zionists is equivalent to sinking Noah's Ark and accepting the destruction of the Jews.

In *Shtisel* the family drama serves to define the larger problems of authoritarianism, especially in the patriarchy. Here the larger political drama threatens the unity of two families. They which find themselves united by a nursery fatality and threatened with disintegration. Implicitly, the film also dramatizes the dangers of destroying the separation of church and state. Explicitly, it plays on the homonymous themes of personal autonomy and atonement,

Episode 1. The occurrence yearned to occur

The title's "occurrence" can be taken to refer to the original postulated separation by the orthodox, the pressure for their reunification or the respective states' confronting each other over the fate of a nine-year-old child, Gonnie. All seem inevitable outgrowths of the current real-world Israel tensions.

Yoni Broide is initially outside that struggle. An orthodox Jew, he uses his Burial Society job — delivering corpses for burial — as a front to smuggle forbidden materials into the Autonomy (the Orthodox state). He still has his principles: He won't put pork next to a corpse. But he sneaks in porn videos and forbidden books. In this culture even children's books are held back if not certified kosher. Broide is surprised to learn that his client for the smuggled Freud and Thucydides is the Autonomy's leader, the Rebbe from Kreinitz.

In asking the Rebbe to pray for him, Broide identifies himself as Yona ben Leah. That is, by his mother's name not his father's. We later learn that his father — a soft, attentive man to whom he was very close — was killed in the yeshiva demonstration that led to the Autonomy's independence. As young Yoni had coaxed his unwilling father to go, the adult Broide feels responsible for his father's death.

Broide seems to grow out of the Lippe character in *Shtisel.* He's torn between the orthodox restrictions imposed on him and his instinctive attraction to secular temptations. Despite — or because — he has a tight family life, with an orthodox wife Blumi and four children, he slips into an affair with the blonde jazz saxaphonist Anna, He meets her when he collects her dead partner Gabriel for his burial in Jerusalem.

In continually calling Anna Hannah, Broide subconsciously stifles the obvious reminder of his wife's name Blumi in Anna's surname Blum. He alters the other name to avoid the problematic one. There's an echo here of Ruchami's "Hanna Karenina," the doomed, romantic heroine she domesticates to fit the Haredi vision. Broide courts Anna with his interest in jazz, proving his sincerity with a melodious "Lover Man."

Broide has a non-religious philosophy. "There aren't enough people for all the pain in the world," he consoles Anna. He turns an adage to seductive purpose: "A Jew mustn't hold back. We're held back as it is." And to the child he's feeding: "Jews have to eat a lot so when the wolf comes he'll have something to devour."

Broide sins but only with difficulty: "I should've been a good person." His recurring "penitence attack...will go away soon." He pauses his first intimacy with Anna to go to the washroom to suppress his conscience, to stave off another penitence attack.

Most of the first episode explains the opening scene, where Asher and Batia Luzzatto are informed there is a "stay of exit order" against their nine-year-old daughter Gonnie leaving the State of Israel. A nurse has just confessed to having accidentally suffocated this couple's newborn daughter. She then switched her wristband with the daughter of Elka and Hilik Rein. The destructiveness of an impulsive, emotional action operates on the family as well as national level.

That news shakes both families. In parallel lawyer scenes both sides determine to "go to war" over the innocent little girl. The Autonomy legal scene is shot dark and sombre, as if pre-Enlightenment. The State one glows in gleaming whites. Gonnie's functional parents are determined to keep her, despite having just decided to separate. Their lawyer insists they conceal this intention, which could destroy their case.

Against her husband's reservations, Elke insists on recovering their lost daughter. She is strongly supported by her father, the Rebbe of Kreinitz, but his motives are suspect. He turns the family tragedy into a national political issue, to reinforce his political control. At a massive rally the Rebbe insists that the child must by Biblical authority be raised Orthodox. "Not one Jewish soul shall be wasted." The Rebbe is an amplification of the callous religious authority that Shulem Shtisel wielded in the writers' earlier critique of patriarchy.

To avoid another civil war, the magistrate suggests a Solomonic compromise: the birth and foster parents divide their weekly time with the child. Elka accepts this but her husband cites her father's patriarchal authority. When the magistrate then decides to leave Gonnie with the parents who raised her, the Rebbe turns his family issue into a political rebellion.

As Shulem did, the Rebbe pretends to divine authority: "We have no choice. It's time to do God's will. We must wage war to recover the child." He diminishes his personal interest: "This is not my granddaughter but the granddaughter of the Jewish people.... We won't let the Zionists steal our children." Echoing the Rebbe's pretence to purity, his daughter's married name is Rein (yiddish for 'clean'). Similarly, her husband Hilik is slightly off 'Heilik' (holy), the way 'Shulem' deviates from the "peace" of 'Sholom.' The Rebbe declares the courts secular idiots who have abandoned the Torah, his source of authority. As the Rebbe incites his people, Broide remembers the yeshiva riot that killed his father: "It starts again."

The Rebbe tries to persuade Broide to kidnap Gonnie for him. Pretending humility, he admits he does not have divine inspiration. But he presumes to know God's will, what God wants of him and of others: "If this is what God wants, you will do it." As Broide leaves, the Rebbe looks away, out his car window, at the darkness. Himself a force of darkness, he will push Broide to criminal lengths for his — a.k.a., God's — will.

To coerce Broide into kidnapping Gonnie the Rebbe unleashes the full force of the law. Police raid Broide's home, forcing him to move all his contraband material into a country bunker. That they then destroy. They intrude upon his son's birthday party with naked force. Cutting himself a piece of birthday cake, a policeman pauses for the blessing on God's gift of various nourishment. The piety can't hide his brutishness.

Here lie the wider range of autonomy issues among the characters. Blumi, Anna, both sets of warring parents, the arrogant Rebbe and especially the conflicted Broide all wrestle with the constant battle between their urges and their external restraints. Autonomy is their every impulse -- and affliction.

As Broide lies in bed, contemplative, his peace assailed by Anna's allure and the Rebbe's demands, the song says "Winter came around one hour too soon. Now I am dancing alone in my room. Rise, rise, only for me." Like Gonnie in the opening scene, Broide is unwittingly

trapped in his own "stay of exit order," imposed by the Rebbe who uses God to enforce his personal will.

Episode 2. A hymn for the homeless.

A variety of homeless or uprooted define the second episode. Some Haredim plead with the Rebbe to allow the reunion of the orthodox and Zionist states. For the Autonomy is suffering economically. Its hospitals are in decline and have been unable to pay salaries for two years. The Rebbe declares these problems to be God's will.

To persuade Broide to kidnap Gonnie the Rebbe insists he has God's intention in mind. He calls Broide evil for quitting his smuggling operation and wanting to be left alone. He should serve God's — *i.e.*, the Rebbe's — cause. As someone capable of wrong-doing, "You can destroy the world, but you can also fix it." To the Rebbe, "the world" is just his will.

The Rebbe's sophistry leaves Broide helpless. The radio jazz catches his secular inclination and his desire for the saxophonist Anna. She's now angry at his revelation — post-coital — that he has a wife and four children. To her "drop dead" he replies "I died a long time ago." In her and in the secular life he hopes for a rebirth, a new life and home.

When he see his bunker contraband burning and learns his children have been expelled from their good schools, Broide feels the Rebbe's power. It is holy but malevolent. That's another homelessness, commitment to a corrupted faith.

Broide's attempt to go straight is also snarled by his reputation. Son Tzviki is alienated after slugging a boy who said Broide was a "shaygetz," literally a gentile, but by implication a rascal. Even Broide's unpleasant job — loading and delivering at a supermarket — is disrupted when his boss Bubchik also calls him that. At Broide's objection the boss shoves him several times. Broide's retaliatory push

accidentally kills him. In jail Broide is at his most homeless, unsupported, vulnerable. He's helpless before the Rebbe's offer to free him in return for kidnapping Gonnie.

Earlier, a pause in the washroom — as in his earlier scene with Anna — enabled Broide to reject the Rebbe's criminal demand. But the murder charge rewrites Broide's life. Again the Rebbe claims God's will: "What more needs to happen for you to know God's plan for you?" For his family's interest Broide agrees. The Rebbe promises to take care of Broide's family and to protect their eventual marriages.

Knowing he will never return home, Broide instructs the Rebbe to deliver to his wife his *get*, his divorce, so she will not remain bound to him. Like the first episode, this one closes on Broide's flashback to his father's death at the demonstration. A second father is lost to his family, this time the first one's son.

The two conflicting families also reflect incompleteness in the home. At their *shabbos* service Elka insists her husband bless their missing daughter as well as their present kids. To her, Gonnie is homeless until she's with the parents she has never known.

Even in her present family, Gonnie is bounced between two incomplete homes. Asher moves from sleeping on the couch to moving in with friend Victor. The playboy's pad is no home for Asher. Batia rejects his reconciliation attempts as suffocating.

In despair Asher makes a serious move against Batia. In an anonymous phone call he informs the Reins' lawyer that Gonnie's adoptive parents are separated. This strengthens the Reins' case. Even more rootless now, Asher hangs himself — but is saved by Victor's timely return home with a date.

As in *Shtisel*, here the plot provides a range of human effort — much malevolent, some desperate, most self-serving — which the ostensibly pious attribute to God. They empower themselves and advance their selfish ends by claiming to be in His service. Compared to them the petty porn smuggler and adulterer Broide seems a moral

exemplar. He at least practices penitence, however frequently and briefly,. He aspires to a better self.

Episode 3. On time and terror

The kidnapping episode is presented on a juggled time-scheme, to evoke the characters' tension, anxiety, confusion, and the moral chaos of the situation. This criminal act is — on both the characters' domestic level and on the religio-political front — a sign of all coherence gone. Like Broide's recurrent flashbacks to his father's fatal presence at the protest, the shifting tenses confirm the continuing influence of the past.

In parallel confessions Broide first tells wife Blumi then girlfriend Anna about the murder and his need to flee. He leaves Blumi weeping helplessly, freed but unwilling to remarry. Told of his enigmatic escape plan, Anna immediately volunteers to help and to leave with him. He assures her his well paid mission is legal because it's on high command. From the Rebbe of Kreinitz himself, he does not explain.

With his sidelocks clipped and wearing a flashy sport shirt Broide is a different man, stripped of his orthodoxy. Another emblem of his new life is the nude painting above Anna's bed. Defining his new culture, this is as quietly eloquent as the crucifix over Lippe's bed in *Shtisel*, when he phones Giti to plan to return.

In a more expensive transformation Broide orders blackmarket passports for himself and for the black-wigged Anna (at $6,000 each). Germany and Hungary are a problem (as usual) so they'll claim to be Estonian. We watch full-screen the passport ID photos transformation. How fluid identity in the secular world.

In a more regrettable transformation Asher, having betrayed Batia by reporting their separation, now cruelly blames her for Gonnie's abduction — as well as having destroyed their home and marriage. His anger and — unacknowledged — guilt turn him cruel. As the kidnap plan unfolds, Anna exploits Batia's new dressmaking business and her

desire to satisfy Gonnie's desire for music lessons, virtues that leave her vulnerable.

After Anna's photo is televised as one of the kidnappers the Rebbe changes the plan, demanding Broide take Gonnie to Kreinitz in the Ukraine. The net tightens around Broide. The police arrest of the Rebbe provokes another riot of religious indignation against the secular order.

The time-juggle allows for one trick on our judgment. At one point Gonnie refers to her abductors as if they were her real parents. We may infer this was their expedient lie. But we later see the earlier scene in which she says she has guessed they *are* her real parents. They do not correct her. When she phones Batia she says she had wanted to meet them but she misses her adoptive parents. She wants them to reunite so she won't have to hear their quarrels. That Batia promises.

In the episode's key discussion Broide tells Anna that he learned real fear when he was nine years old. It's the wound he has learned to live with since. Again the episode closes on that primal scene — his father's murder in the riot. "You can't take fear to the grocery store," Broide advises. But it enables his desperate attempt to salvage his spirit and to make a new life.

Episode 4. High walls in the heart

The title points to both the personal and socio-religious obstacles to ardent commitment. At the episode's core is the Jonah story that Broide tells Gonnie, to calm her as a truck smuggles them across the border. The story proves "You can't run away from God the Almighty." Jonah's attempt imperils the ship on which he is fleeing God's assignment. That results in the storm, his ejection and his swallowing by the whale. In despair and alienation Jonah stumbles through the darkness inside the whale: "like here inside the truck's belly."

The police station scenes present a range of isolations. The Rebbe and the conflicted mothers are interviewed in separate rooms. As ever

wielding his religion against the law, the Rebbe fends off interrogation by praying and citing homilies: "The angry man is governed by all sorts of evil." So, by the way, is the self-serving patriarch.

When Batia is brought in to meet Elka the police fear there may be violence. Instead the women's emotions bridge their antagonism. "I just want to know [Gonnie's] all right," says Batia, logically suspecting the birth-parents are behind the abduction. When Elka approaches her, her intention is not aggressive: "Feel my heart. I would never do that to my child." Later Elka visits Batia at home to make a joint public appeal for Gonnie's safe return. She surrenders her claim: "Do not fight on our behalf. We have had enough of war." The voice and values of motherhood oppose the patriarchal ardor for self-righteous war.

Elka was converted to Batia's side by the Rebbe's unwitting confession. Though he denies responsibility for the kidnapping, he reveals how it serves him. He claims that God planned the problem of Gonnie's parenthood to prevent the Autonomy from returning to the former unified Israel. Gonnie has saved the orthodox "from that crisis of unity." Elka sees his real purpose — to extend his rule over the Council and the public. "Is this how you see your father?" he asks in weak indignation.

When the Council meets — in the Rebbe's house, for his additional pressure — he claims that past generations of Jews are watching them, demanding their "right choice for Israel," their independence from the modern State. He receives no support.

In a brief scene Leibish transmits Broide's divorce to Blumi. She responds with tears and concern for her children, "who love him so much."

Gonnie's opposing fathers respond differently to their wives' initiative. When Batia insists she will not leave the Israeli police station until Gonnie is returned to her, he finds her sleeping erect. Despite having blamed her for the abduction, now he plants a tender kiss. That provokes another rejection: "Moron!"

In contrast, Elka returns home to find her Hilik leaving her. Her television appearance has undermined the Autonomy. He doubts her ability to raise their children. When the Luzzattos hear Gonnie has been found, they refuse to wait upon the Ukrainian police and hie themselves off to Kreinitz.

The Rebbe has three responses to his (supposedly religious) political defeat. The stress results in his hospitalization and minor surgery. By his homily, "A living dog is better than a dead lion." With his political intention thwarted, he can fall back upon proper fatherliness. He tells Elka he now supports Gonnie's return to the Luzzattos. The TV appearance persuaded him which Jewish mother should hold sway. Instead of admitting political defeat he pretends to respect familial emotion. This is not quite the wisdom of Solomon. He despatches Elka and Hilik to Kreinitz with the money to pay Broide and to retrieve Gonnie.

But the Rebbe tries to rebuild his political hold. He calls on the yeshiva students to immediately go to Kreinitz to establish the orthodox enclave threatened by the reunion of Israel. They will buy back the original yeshiva building, at whatever cost, to save it from its current function as a gentile cinema..

More sappily, the Rebbe ignores the healthiness that bodes his imminent release from the hospital. Instead he pretends a deathbed request of his faithful aide. Though older, the personal assistant has been like a son to him so would he please say his *kaddish* (the prayer for dead). With apt bathos, the Rebbe also urges him to stop drinking so much Coke. As with the enemy cinema, the secular ever intrudes upon the religious. (Despite his healthy prognosis, in the last episode the Rebbe dies in disappointment.)

Nor does the kidnappers' course run smooth. At the Ukraine airport the "family" are taken aside for questioning about their Estonian passports. Broide qualifies by reciting the first lines of *Genesis* in Estonian. As the interviewing woman continues to scrutinize them suspiciously, Broide disarms her: "You look at me a lot. A lot. I look

good." Smiling, she returns their passports and admits them. "We go to rob a bank," Broide assures her. "You can come."

Her suspicion concerns them, though. Afraid of being recognized, Anna loses her black wig and Broide shaves his full beard and — to Gonnie's suspicion — doffs his *yarmulke*. Gonnie has cooperated fully so far, even giving the border official her assumed Estonian boy's name. But when Broide eats a *traif* sandwich on the train — which makes him privately vomit — Gonnie concludes that the couple are not her real parents. When they disembark at Heinitz, Gonnie jumps back on the departing train.

One detail requires special attention. Gonnie's boy-cap bears the label "Why." So, why?

First, the word is a question. Why is Gonnie in this situation? What religious or moral principle has been served by casting her into a familial tug-of-war, then an abduction? Why should she be obliging her ostensible "parents" who are neither her birth nor adoptive ones? Why should this nine-year-old suffer an uprooting trauma like the nine-year-old Broide did?

More broadly, why was she switched away from her parents in the first place? Was this an accident, a human error, a quirk of fate? Or was it indeed an act of divine intervention? That the Rebbe contends — and may or may not actually believe.

In *Shtisel* the writers often posed this question, however implicitly. "We are all in God's hands; we know nothing," the characters often claim, especially around funerals. But this can also seem a convenient, evasive denial of human responsibility. Thus Nachum always blames others for his financial problems.

But also as in *Shtisel* the writers leave open the possibility of divine intervention. Why did Lippe call to report Malka's coma just in time to abort Giti's abortion? Why did Ruchami's glue not work when she posted Lippe's humiliation? Of all the kugel joints in Jerusalem, why did Hanina for his pre- divorce court lunch choose Giti's restaurant? Divine direction, accident, or was he returning to the scene — under

new ownership — of his impromptu wedding? The writers are respectful enough of religion to allow the possibility of divine intervention, even as that may seem to lessen human responsibility.

But the "Why" word is also an answer. This child is the reason two factions are fighting for her. But they have different compulsions, different "whys." To the Rebbe she is a useful instrument for his personal advantage, in the name of a religious cause. That feeds Elka's and Hilik's blood-claim on her, which is as tribal as the Rebbe's authority. To the Luzzattos she is the child they have raised and love. She is also a new reason to renew their marriage, to give her the comfortable family she craves. Perhaps Batia — with her new career, self-assertion and recovered daughter— can give the marriage a second chance, as she has promised her. Gonnie is the "why" of her cap.

Beyond the family, Gonnie is the future generation, the "why" for which the liberal Israel here focused on the State, capital Tel Aviv, is in conflict with the orthodox Autonomy, centered in Jerusalem. Here this dystopian fiction reflects a radical tension in the real Israel today. How will the next Israeli generation(s) be raised? Will they be prepared for the challenges and with the opportunities of the advancing world or will they be stuck in old customs and limits? This battle over Gonnie is the battle over what Israel will become.

Then there is the theological "Why?" "Why, Lord?" ask Moses, Abraham, Jonah, Job. And so say all of us. Comes the answer: "That's why!"

The drama is not over yet. As the title of the final episode warns:

Episode 5. Things turn out differently

As the previous episode was the first not to close on Broide's flashback to his father's murder, this one opens on that old riot and closes on the new one. The first shot is unique composition in this series, a bird's eye — a.k.a. God's eye — view of the historic riot's aftermath. At the dark four-way intersection a line of corpses lie in the

middle, with black-suited witnesses behind them. The ambulance flashes at the left. The shot seems to be another, larger "attack of remorse. It'll pass in an instant."

At episode end Broide awakens in a yeshiva to find the students wielding molotov cocktails against the IDF rifles, deployed to enforce their conscription into the army. As the Autonomy has been annexed into the State, the government is enforcing the army's claim on all its citizens. The education department is raiding the yeshivas to enforce the addition of basic secular education.

In between, the kidnapping plot stumbles to conclusion. Gonnie turns herself in to the conductor, who leaves her with the local police. When the two sets of parents meet across the tracks at Kreinitz, with no sign of Gonnie, Asher attacks Hilik, leading to both men's arrest. In the station Batia spots Gonnie and they rush to each other. As the adoptive family leave, Gonnie impulsively runs over to Elka and gives her a long hug. Now she seems explained by the word "Explore" on the shoulder of her jacket. Hilik notes how like Elka the beautiful Gonnie looks. We expect both families' unification.

As Broide and Anna try to find Gonnie (and the money owed him) they are variously distracted. To counter his first frightening flashback Broide urges the non-believing Anna to join him in a hymn. That "Song of Ascents" is what Shulem had his class sing in a protest and that he sang at his ECG. Broide dispels Anna's doubt: "Someone is always listening."

Broide wins an old Lada from a rural barkeep by beating him in a chess game. "You're sure you're not Jewish?" the defeated stranger asks. Expecting prejudice, Broide had denied his faith. He tells Anna he learned chess from his father, a soft man who played him chess every Friday and only once let him win.

Because his father placed more faith in the Torah than in protest he didn't want to go to the yeshiva demonstration. But young Broide insisted. "I still don't know why God Almighty refused to let my father

come home." He repeats the dubious — but possibly assuring — distinction between human agency and divine intercession.

Broide has been revealing himself only haltingly, to Anna so to us. For: "Broide is like a sausage. Better not to know how he was made." The simile conveys his low regard for himself, ever penitent, ever sinning. Yet he has been showing an increasingly moral and humane character. He offers a ride to a cold pedestrian and gives him his own jacket: "Some Jews aren't human beings, but all human beings are Jews." That jacket enables Broide to escape his own identity. When he survives his stalled car's ramming by a train, the stranger is reported to be the dead Broide.

Again the question of human agency arises. Did God inflict the fatal crash on Broide to punish his licentiousness with Anna? But save him because of his kindness to the stranger? Or was it all just another case of human impulses and unintended consequences? At least until Judgment Day the jury is out.

Here that day comes soon enough, in the dream during Broide's six-month coma. Like Shulem's dream of the Day of Judgment in *Shtisel*. Both provide the character's renewal of spirit, a rebirth. In both dramas, the writers make the metaphysical world as "real" as the characters' waking life.

As the various people wait to be judged by the Heavenly Court, Broide is surprised to meet the esteemed Rebbe. He too waitis to be judged. For once he is uncertain of his fate: "I don't know if I fixed more than I broke or if I broke more than I fixed." Now he admits that with the Almighty "Even when you intend to do His will He may see it differently." He seems to acknowledge the sophistry of claiming God required Broide to kidnap Gonnie. Indeed the Rebbe asks Broide to intercede, to sing "Peace Unto You" for him. He asks for Broide's forgiveness.

After Broide recovers consciousness in a Ukraine hospital he returns to Jerusalem. From his taxi he sees a fragment of his funeral poster on

the wall, then Blumi, with her new husband, two of their children and a new infant. Broide asks the cabbie to drive away, anywhere.

Assured that his family is secure and whole, bereft of his Anna, the man who was torn between the orthodox and the secular life finds he cannot escape the trauma he experienced at the age of nine. As he lost his father in the riot that gave birth to the Autonomy, he awakens into another yeshiva riot protesting its end. To avoid joining the army they wage war against the Israeli military.

Broide leaves his cane, takes a black suit jacket and hat and picks up two molotov cocktails. We think he will join the throwers. Indeed the television news reports that he set fire to himself to protest the annexation.

To the contrary, however, Broide seems rather to emulate the Buddhist monks' self-immolation in protest against the Vietnam war. As in the parallel *Shtisel* episode, the Judgment Day experience transcends religious distinctions. Broide was never dutifully orthodox and he was always haunted by the human costs of the campaign for autonomy. Indeed his personal autonomy has been the drama's primary victim of the Autonomy's war against the State. In his final and fatal act Yoni Broide at last performs what he takes to be God's will. He won't fight either the unifiers or the rebels. Instead he sacrifices himself in protest against their war. Paradoxically, in self-immolation he finally asserts his own will.

Broide's climactic atonement for his father's death and his own loss of moral will contrasts to the Rebbe's sophistical claim to having wanted to atone for the first yeshiva deaths. It coheres with the young nurse's finally confessing to her baby switch in the nursery, when she switched the baby she killed for the more newly-born one, to prevent suspicion.

Broide's truth is buried in the news, in the public presentation of the event. As a reminder that the drama's war continues, the same news broadcast promises an upcoming report on the mass exodus of Autonomy Jews to revive the old settlement in Kreinitz. There the rural

barkeep watches that news, soured at the prospect of more Jews to best him at chess.

Not that he has anything against Jews.

About the author

Maurice Yacowar is Professor Emeritus (English and Film Studies) at The University of Calgary. In his 44-year academic career he was Dean of Humanities at Brock University (St. Catharines, Ontario), Dean of Academic Affairs at Emily Carr Institute of Art and Design (Vancouver, BC), and Dean of Fine Arts at The University of Calgary (Alberta), where he retired in 2006.

His books include: *Reading Shtisel* (lulu.com, 2019; second, expanded edition 2019); *Roy and Me: This is not a Memoir* (Athabasca University Press, 2010); *Mondays with Moishe* (humour: lulu.com, 2009); *The Great Bratby* (Middlesex University Press, 2008); *The Sopranos Season Seven* (lulu.com, 2007); *The Sopranos on the Couch: Analyzing TV's Greatest Series* (Continuum, 2002; expanded editions, 2003, 2005; 2006); *The Bold Testament* (humour: Bayeux Arts, 1999); *The Films of Paul Morrissey* (Cambridge University Press, 1993; Spanish edition, 1999); *Studies in International Cinema* (B.C. Open University telecourse, 1992); *Method in Madness* (St. Martin's Press, 1981; expanded edition by W.H.Allen as *The Comic Art of Mel Brooks*, 1982; expanded edition, Crescent Moon, 2015); *Loser Take All: The Comic Art of Woody Allen* (Frederick Ungar, 1979; expanded edition, Continuum Press, 1991); *I Found It At The Movies* (Revisionist Press, 1978); *Tennessee Williams and Film* (Frederick Ungar, 1977); *Hitchcock's British Films* (Shoestring Press, 1977; revised edition, Wayne State University Press, 2010); *No Use Shutting the Door* (Fiddlehead Poetry Books, 1971).

Dr. Yacowar provided the commentary on the Criterion editions of *Blood for Dracula*, Paul Morrissey (1996; DVD 1998); *Flesh for Frankenstein*, Paul Morrissey (1996; DVD 1998); and *Invasion of the Body Snatchers*, Don Siegel (1987). For decades he reviewed films in journals, newspapers and Canadian radio and TV. He provides "instant analysis" of select current films on his blog at www.yacowar.blogspot.com. Dr. Yacowar lives in Victoria, B.C., Canada, with his wife, Anne Petrie (who's not chopped liver herself).

Jack M. Barrack Hebrew Academy
272 S. Bryn Mawr Avenue
Bryn Mawr, PA 19010

29 March 2022

17666441R00046